Cocaïn

History &
Culture

ARMAND LIMNANDER

Cocaïn

History & Culture

ASSOULINE

Introduction

The question is posed by a perfectly pleasant lady to her and her husband's well-to-do, pseudo-intellectual dinner guests: "I don't believe it. You mean to tell me you guys have never snorted coke?"

The two couples are relaxing on a plush sofa in a comfortable, well-lit Manhattan apartment. The dress code—khakis and sweater vests, buttoned-up blouses—suggests off-duty Upper West Side academics rather than downtown party animals. There's no talk of going out; doing a line or two is simply meant to provide an at-home frisson of excitement. It's also maybe an excuse to show off a little: Cocaine is cool, hard to find, and not cheap. The "stash," the husband explains, is worth about $2,000, and was procured in faraway California.

"Do your body a favor, try it!"

The scene is, of course, from Woody Allen's famous *Annie Hall,* from 1977. It ends with Alvy, the bumbling character played by Allen, cautiously dipping a finger in the precious powder and touching it to his nose—and then vigorously sneezing, thus obliterating the party favors. That film, perhaps better than any other of the era, captured how prevalent cocaine had become. If these urban middle-aged folks were doing it, who wasn't?

In the popular imagination, cocaine appeared sometime in the 1970s, seemingly out of nowhere, as the *ne-plus-ultra* party drug for the disco generation; shortly thereafter, it became the pick-me-up of choice for yuppie Wall Street traders. That is, as we shall see, an understandable mistake, because cocaine wasn't just a passing fad, like bell-bottoms, feathered hair, and platform shoes. Its history dates back to 1860, and its forebear, the coca plant, has been a vital part of indigenous South American cultures for millennia.

We are all acutely aware that over the past few decades cocaine has become a global scourge responsible for intractable addictions, countless drug wars, near-collapses of inner cities and governments, and the rise of organized crime and homicidal gangs. But not many have focused on a different and fascinating story: how coca, considered a sacred plant in pre-Columbian times, traveled a long, treacherous road to become coke, blow, snow, powder, nose candy, Charlie, cha-cha, flakes, base, C., and all of the other evocative monikers by which cocaine is now known.

The famous cocaine scene from Woody Allen's *Annie Hall,* released in 1977. *Following pages:* Photographs taken inside New York City's famous Studio 54 in the 1970s often featured the "cocaine moon." It was emblematic of the club's reputation for glamour and debauchery.

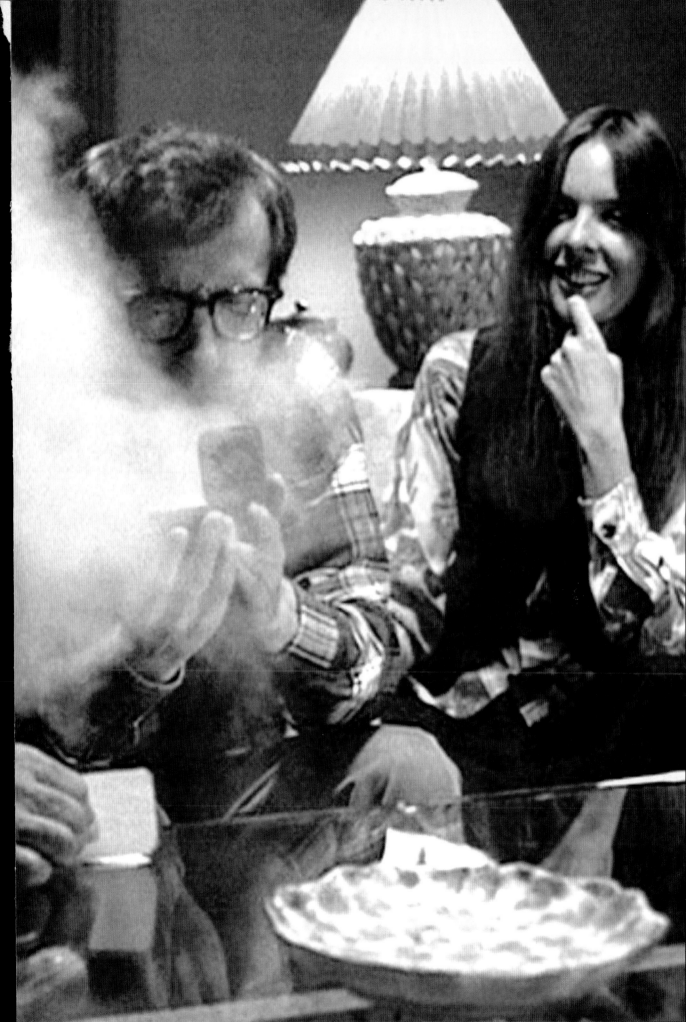

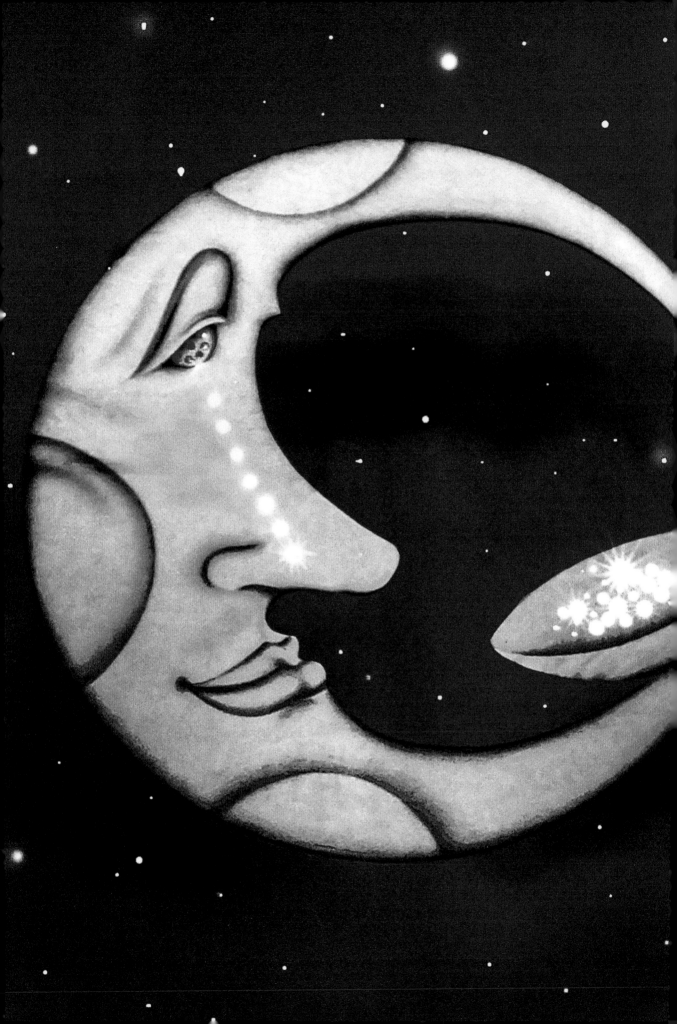

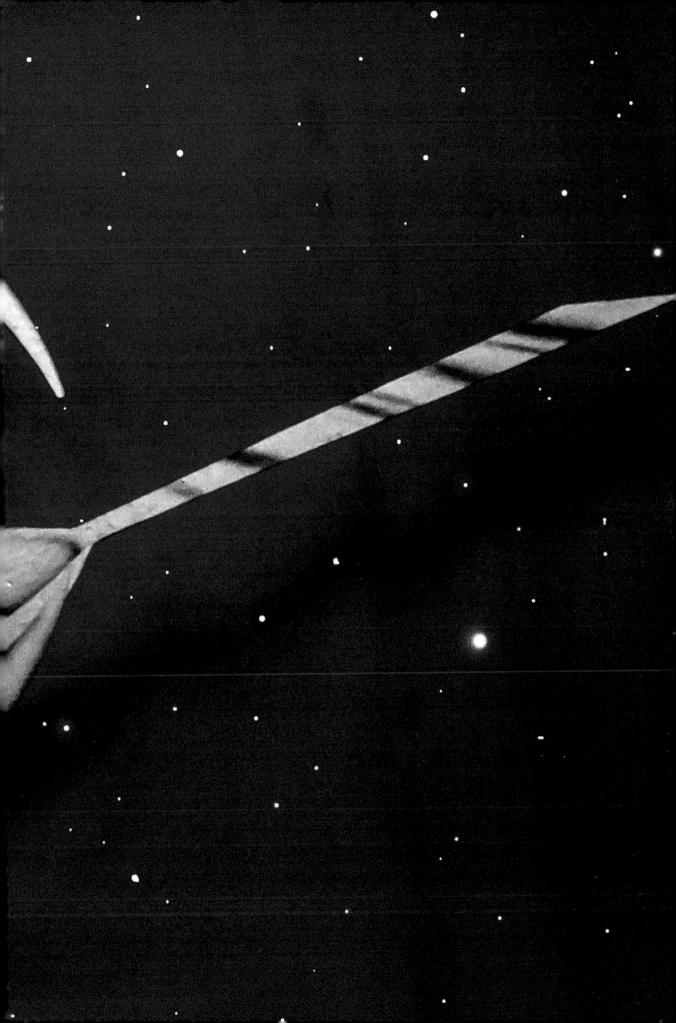

40

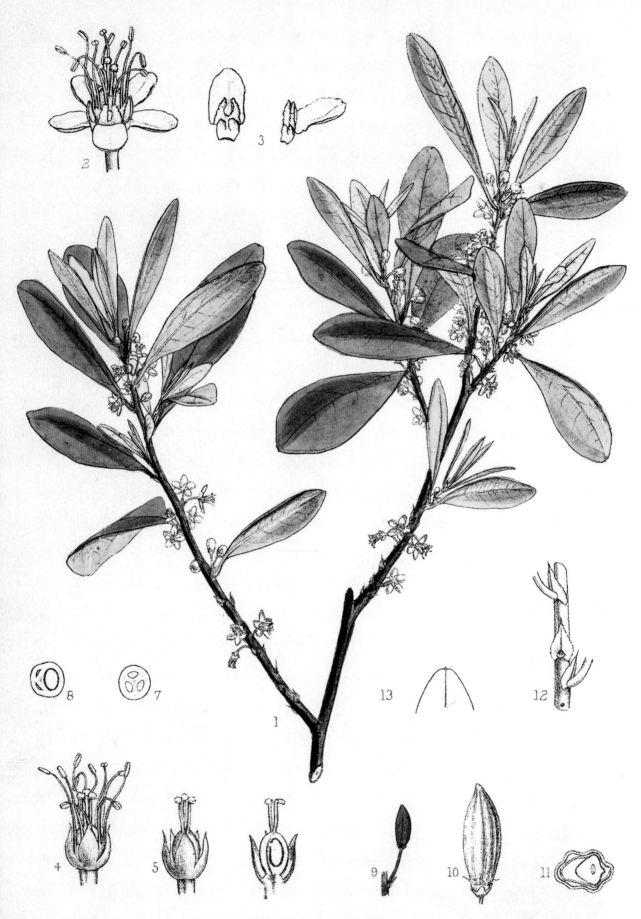

D.Blair, ad nat. del. et lith.

ERYTHROXYLON COCA, *Lam.*

M.&N.Hanhart imp.

The Divine Plant
of the Incas

When the Spanish *conquistadores* arrived in South America, shortly after Christopher Columbus's discovery of the New World, they found an almost limitless natural bounty. Chief among their priorities, of course, was ferrying back to Spain as much gold and silver as humanly possible, but the Americas also yielded many other exotic products, such as corn, beans, tomatoes, peanuts, chocolate, and tobacco, that were new to Europe.

Another discovery, potatoes, would go on to change the history of the world by ending famines in northern Europe and setting the template for the modern agro-industrial complex—especially when paired with Peruvian guano, the world's first intensive fertilizer. The lowly tuber had acquired such cachet by the eighteenth century that Marie Antoinette adorned her coiffure with potato blossoms and Louis XVI wore them as his boutonniere. French farmers were encouraged to grow the peculiar new crop, and diners were pressed to expand their culinary horizons.

One plant that didn't initially attract much attention, however, was an ordinary-looking shrub that stood about seven feet tall, with thin, tapered oval leaves and creamy white flowers that matured into red berries. It quietly and effortlessly thrived in warm valleys along mountainsides at altitudes between 1,500 and 6,000 feet. But *Erythroxylon coca,* as the plant eventually became known, along with other varieties such as *E. novogranatense, E. truxillense,* and *E. bolivianum,* was among the most important staple crops in South America. It was cultivated extensively in what is now Peru and Bolivia, as well as in Chile, Ecuador, and Colombia, and throughout the Amazon basin. It, too, would eventually have enormous and lasting impact—albeit not as beneficial as that of the potato—around the world.

When the Spanish arrived in Peru, in the early sixteenth century, the Inca civilization was at its zenith. Likely the largest empire in the world at that time, it stretched from

A scientific depiction of the coca plant.
Following pages: A ceramic pot from the Moche civilization.

the southern tip of Colombia to northwestern Argentina and central Chile, with Cusco as its capital. Population estimates of the empire vary considerably, but twelve million seems to be a safe bet. Although the Incas did not have wheeled vehicles, animals to ride or farm with, iron or steel implements or tools, or a written language, they somehow accomplished amazing feats: a highly sophisticated network of roads spanning about 40,000 kilometers, throughout their entire territory; monumental architecture; successful agricultural techniques; a complex system of record-keeping based on knotted strings; impressive textile design and production capabilities; and a regimented structure of government and labor. None of it would have been possible without coca.

It's been widely accepted that coca has been consumed in the Andes for about 3,000 years, but more recent archaeological evidence suggests that it was a part of cultures there as far back 8,000 years. Regardless, it's always been treated with reverence. Ancient pottery found on the northern coast of Peru depicts coca users—likely priests, who relied on it for shamanistic, religious, ceremonial, and medicinal purposes. Coca leaves, as well as meticulously woven baskets and animal-hide purses used to store the leaves in, were often placed with the dead, presumably to invigorate them for their journey to the afterlife.

Among the living, coca was used to facilitate trances to communicate with spiritual forces. *Yaravecs*, court orators who were entrusted with preserving Incan oral history, used it to enhance their memories. *Chasquis*, relay marathoners who traveled great distances on foot to transmit messages across the empire, sometimes bearing heavy loads, counted on it to suppress their hunger, thirst, and pain and to provide endurance.

Of all coca's myriad attributes, the one that caught the eye of the Spaniards was, not surprisingly, its ability to

Following pages: (*left*) A glass specimen jar of *Erythroxylum coca* leaves dating back to the late nineteenth century. (*right*) Women gathering leaves from coca plants, 1897.

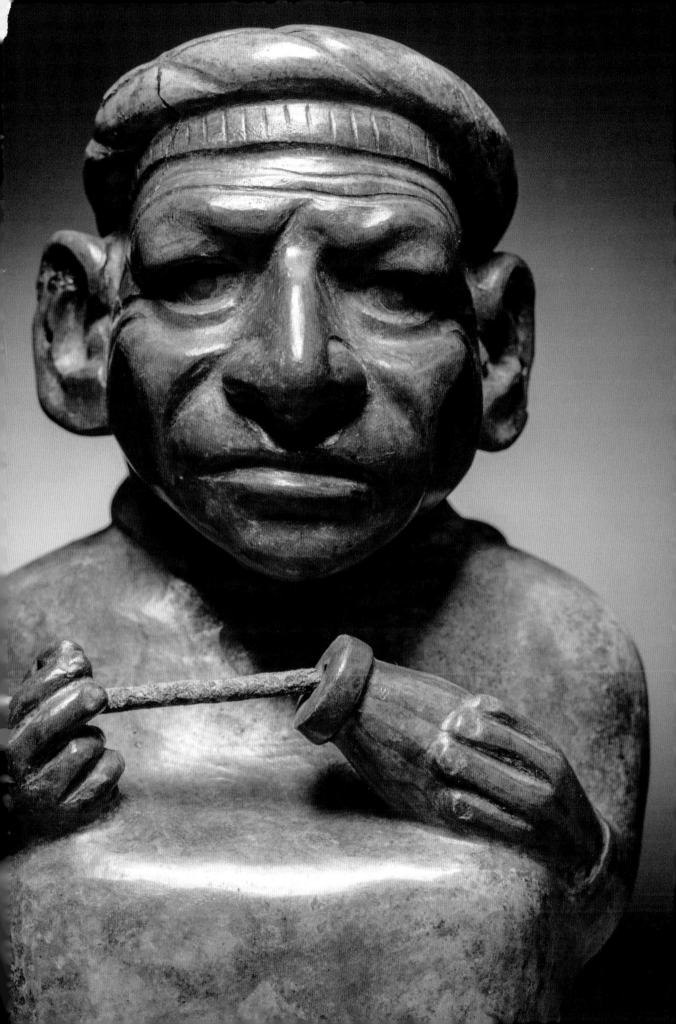

A656870.

COCA
Erythroxylum Coca Lamk.
Erythroxylaceae
Leaves from Peru

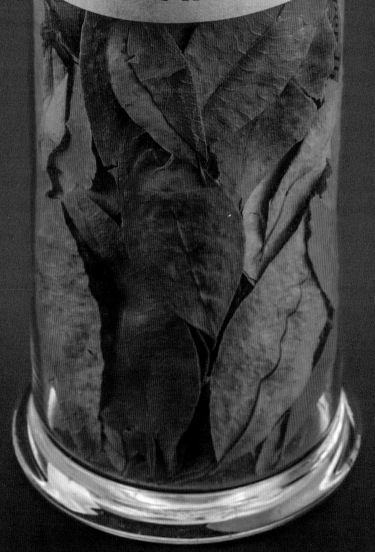

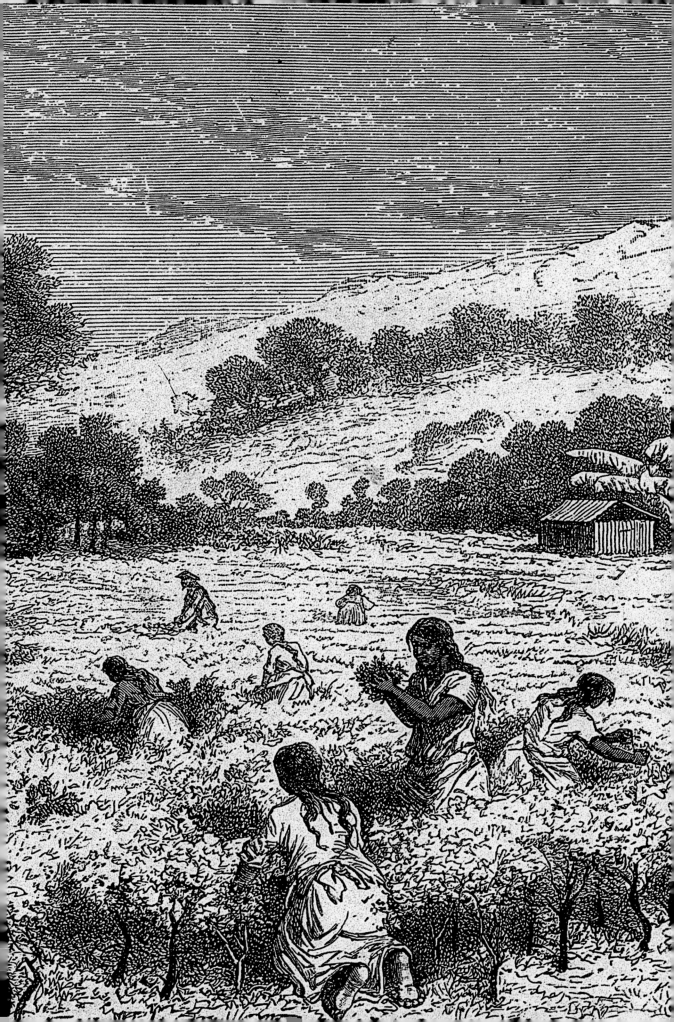

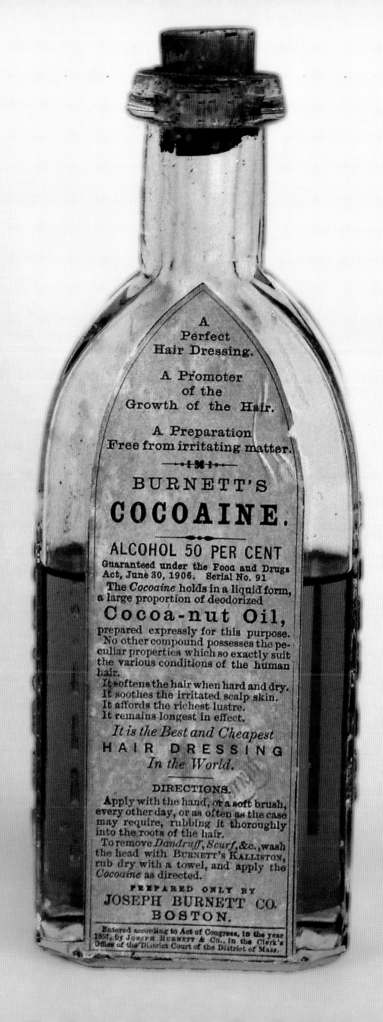

increase stamina. Once they'd moved from the conquest phase of their endeavors on to the colonization of the lands—and, let's not mince words, the savage exploitation of the indigenous population—finding hardy workers who could mine the land for days on end under extremely punishing conditions was of paramount importance.

Labor was not as abundant as one might have thought: Native tribes were decimated, if not annihilated, after the discovery of the Americas. The *conquistadores'* ruthlessness and cruelty has been extensively documented, and their superior military power was a given—they had horses, steel swords, armor, and muskets—but the main culprit was far more insidious. Old World diseases, such as smallpox, chicken pox, yellow fever, malaria, measles, and influenza, quickly spread among the indigenous population, who had no immunity to the germs; they succumbed at devastating rates. Just one example: When Christopher Columbus encountered the Arawaks in what is now Haiti, in 1502, their population numbered 250,000. Fifty years later, only 500 Arawaks remained. It is estimated that at least 90 percent of the pre-Columbian population perished from disease by the end of the seventeenth century. (The native Americans returned the favor as best they could, bestowing upon their unwanted guests the less-fatal but nonetheless lasting gift of syphilis.)

After some largely symbolic hand-wringing by the Catholic Church, the Spanish gave laborers coca as they worked for days on end without sleep in mines and on plantations. In some cases, coca became the workers' main—if not only—form of payment and sustenance. Contrary to popular belief, the leaves were never chewed; instead, they were folded into small bundles containing a pinch of a strong alkaline powder made from limestone or burned roots and then placed between the gum and the cheek. (The powder raises saliva's acidity level, allowing for the active components of the plant to be more effectively absorbed.) To this day, indigenous communities and scores of manual laborers legally consume coca in this manner throughout Bolivia and Peru. Coca teas are widely available in grocery stores and are frequently used by tourists to combat altitude sickness and upset stomachs.

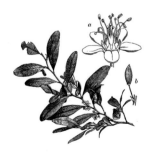

An illustration of *Erythroxylum coca. Opposite:* A Bolivian coca box. *Previous pages:* (*left*) A Peruvian carafe of "La Coca." (*right*) Coca leaves from Peru.

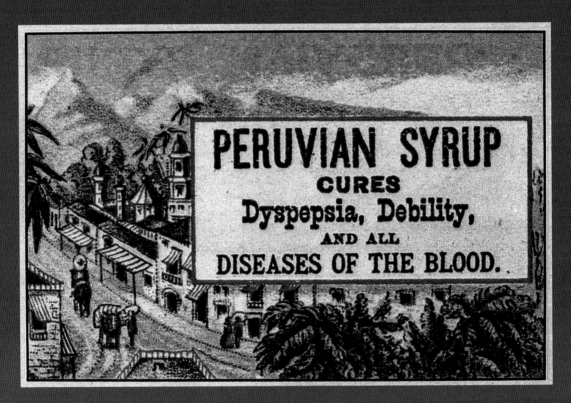

A merchant postcard for Peruvian Syrup.

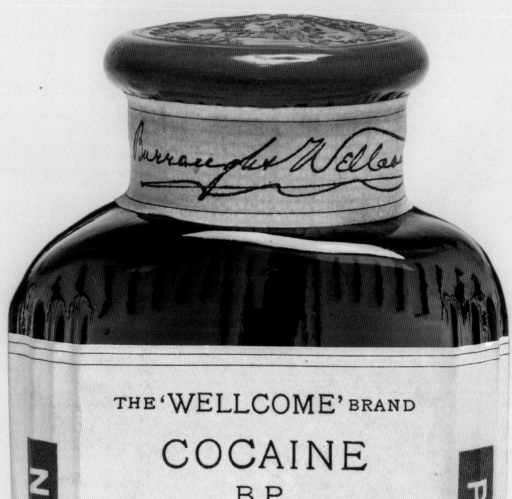

COCA DES INCAS

VIN
TONIQUE & RECONSTITUANT.

J.B. BLANJOT

26, Rue de Pontoise PARIS

IMPRIMERIE. PAUL DUPONT. 4. RUE DU BOULDI. PARIS.

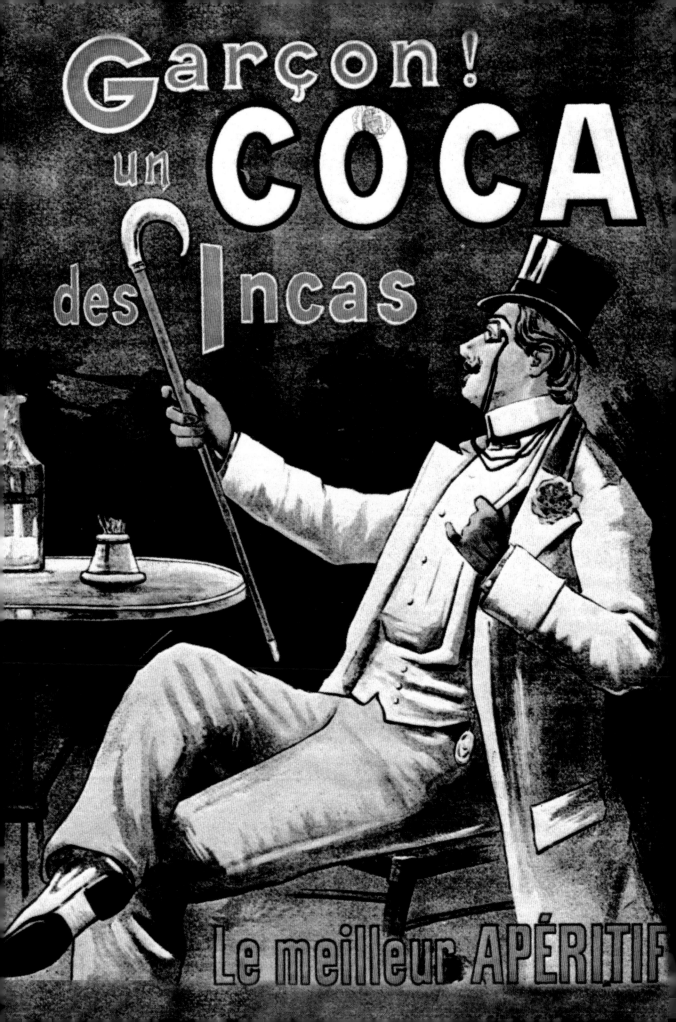

" *Oh, I'm sure it's a lot of fun, 'cause the Incas did it, you know, and they were a million laughs.* **"**

ALVY SINGER,
ANNIE HALL, DIRECTED BY WOODY ALLEN, 1977

A 1906 advertisement from the *British Medical Journal* for Savar's Coca Wine. *Previous page:* Coca des Incas was a highly coveted beverage, mainly because of its sweet taste and —of course—its powerful influence over the body and mind.

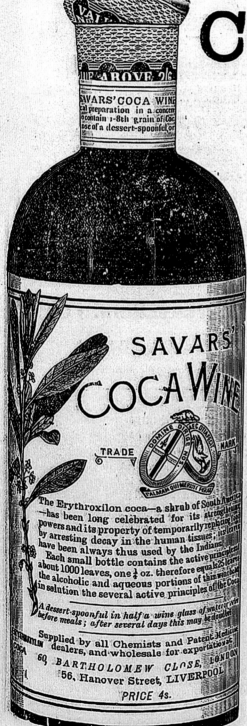

TEN REASONS WHY
COCARETTES
SHOULD BE USED BY ALL SMOKERS.

1st.—They are not injurious.

2d.—They are the most agreeable and pleasant "Smoke."

3d.—They are made of the finest Sun-cured Virginia Tobacco.

4th.—They have the exact proportion of genuine Bolivian Coca leaf combined with the finest flavored Tobacco, to produce the most delicious flavor.

5th.—The Coca neutralizes the depressing effects of the Nicotine in the tobacco.

6th.—Coca is the finest nerve tonic and exhilarator ever discovered.

7th.—Coca stimulates the brain to great activity and gives tone and vigor to the entire system.

8th.—Coca and Tobacco combined, is the greatest boon ever offered to smokers.

9th.—Cocarettes can be freely used by persons in delicate health without injury, and with positively beneficial results.

10th.—The Rice Paper used in wrapping Cocarettes is furnished by Messrs. May Brothers, New York, who are the American members of the celebrated French firm that for over 150 years have supplied the trade with this paper, the secret of making which was discovered by their ancestor Henry May. This paper, as now made by the house who conducts its enormous business under the style of "Compagnie Parisienne des Papiers a Cigarettes Francais," burns completely away, leaving no ashes whatever; it dies away in a thin vapor and the smoker inhales only the smoke of the Cocarette.

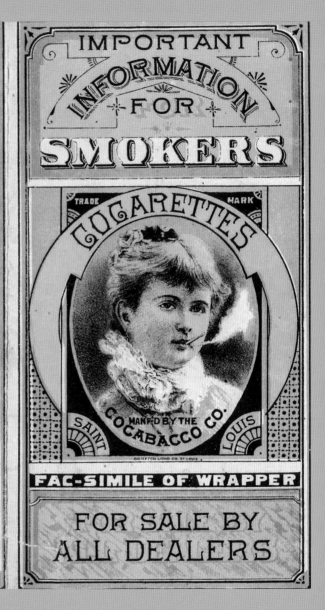

An advertisement for Cocarettes, a cigarette that combined cocaine and tobacco.

From Coca to Cocaine

Surprisingly, it took a while for coca to make it to Europe, though not due to lack of interest. Its applications for the military, for one, were tantalizing—imagine if soldiers could carry on day and night, without sleep or rest!—but the plant didn't flourish in European climes, and its clippings didn't travel particularly well. It was a stroke of luck when, in 1859, the *Novara*, a ship sent to circumnavigate the world by the Austrian Emperor Franz Joseph I, returned to port with thousands of scientific samples from the New World, including a large, unspoiled bale of coca. This was a time of great advances in chemistry: Decades earlier, morphine, quinine, and caffeine had been isolated for medical use. There was a keen awareness that certain plants contained elements—named alkaloids—that could be used as powerful drugs for humans. The *Novara*'s coca trove, therefore, was dispatched to the University of Göttingen, where a PhD student named Albert Niemann successfully derived, for the first time in history, a consumable crystallized form that he named cocaine.

While this was happening in the relative obscurity of the laboratory, travelers were returning to Europe from the Americas singing coca's praises after experimenting with it in markedly different ways than the indigenous people of the Americas. Especially influential was Paolo Mantegazza, a respected Italian doctor who in 1859, after a long sojourn in Peru, published a paper about his experiences with coca. It wasn't uncommon at the time for scientists to study a new substance by trying it for themselves, but Mantegazza clearly went further than was required for his scholarly pursuits. With a less-than-academic tone, he reported that following a coca binge, he had "sneered at all the poor mortals condemned to live in the valley of tears" while he, "carried on the wings of two leaves of coca, went flying through the spaces of 77,438 worlds, each more splendid than the one before."

It wasn't long before someone figured out how to commercialize this tantalizing new product. Anticipating that European consumers would balk at the idea of stuffing their mouths with greenery, like bovine unsophisticates, a Corsican chemist living

Following pages: (*left*) A glass bottle of cocaine eye drops by Burgoyne Burbidges and Co., London. (*right*) A colorful advertisement for Hall's Coca Wine, one of the first commercial products that used cocaine as an ingredient.

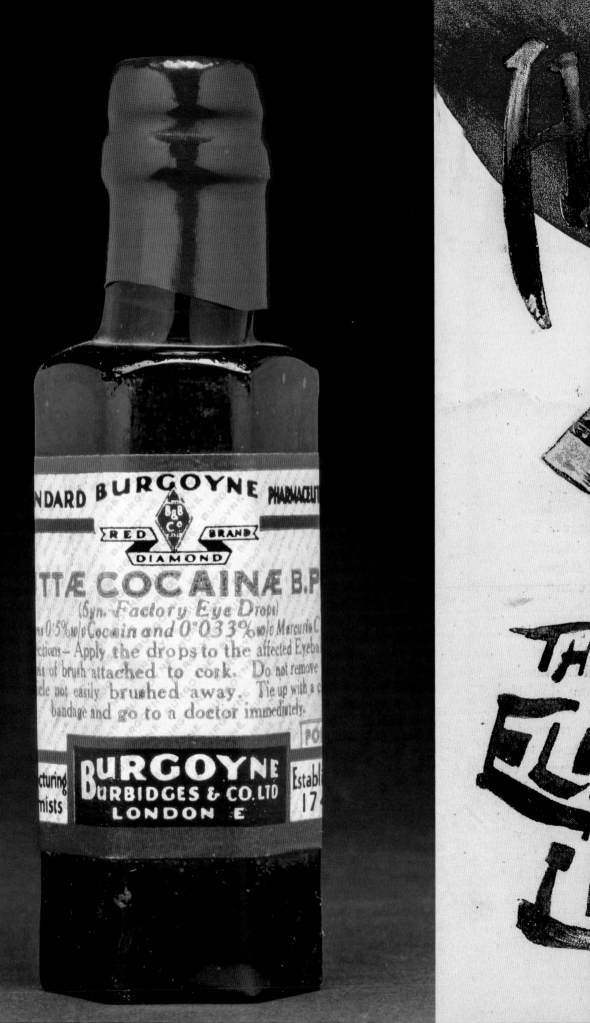

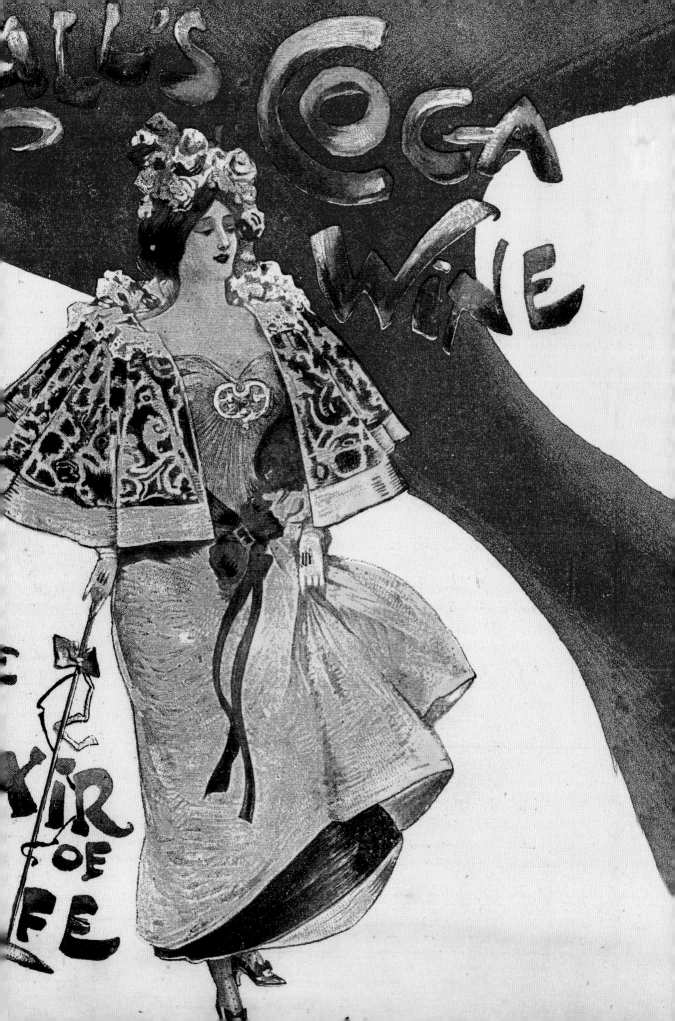

In 1863, with great fanfare, Mariani launched Vin Mariani, a "general tonic" for vitality. It contained six milligrams of Peruvian coca per ounce of wine, and the recommended dosage was two to three glasses a day for adults and half of that for children.

An advertisement for another potential inspiration for today's Coca-Cola, Kola-Coca. *Following pages:* (*left*) An empty bottle of Vin Mariani. (*right*) A late-nineteenth-century advertisement for Vin Mariani, promoted by acclaimed French novelist Émile Zola.

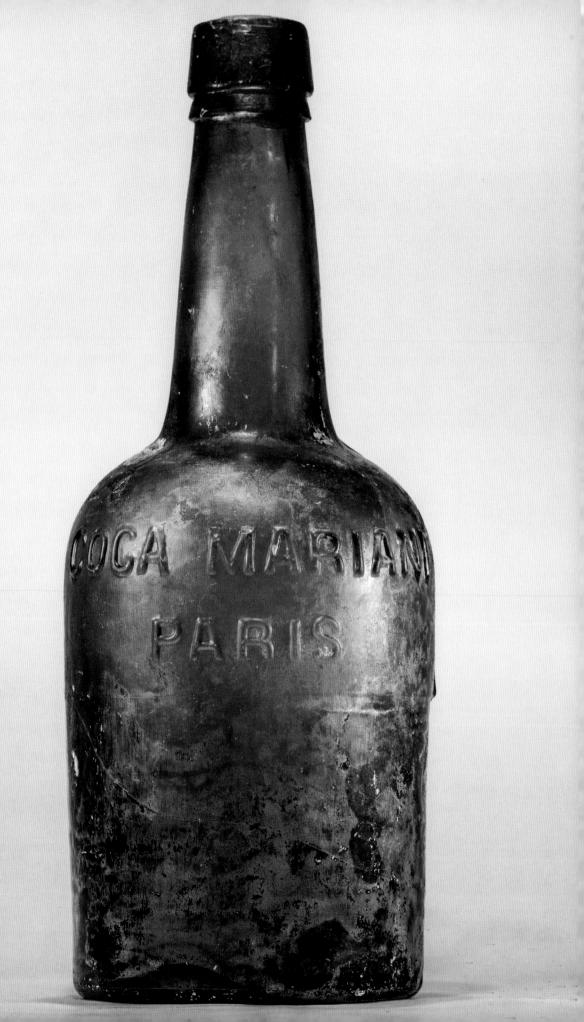

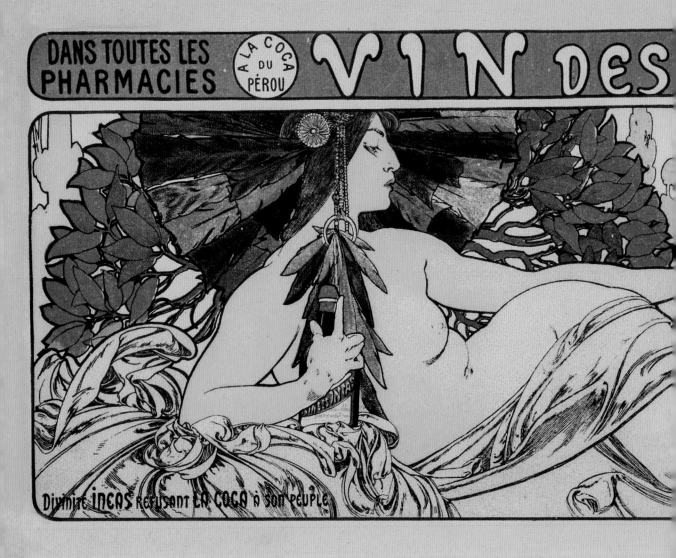

in Paris named Angelo Mariani decided to steep coca in wine—an idea that proved to be visionary, as the alcohol was able to leach the alkaloids from the leaves and simultaneously disguise their unpleasant taste. (Furthermore, when alcohol and cocaine are mixed, they create a third, unique drug called cocaethylene, which magnifies cocaine's euphoric effects.) In 1863, with great fanfare, Mariani launched his brainchild: Vin Mariani, a "general tonic" for vitality. It contained six milligrams of Peruvian coca per ounce of wine, and the recommended dosage was two to three glasses a day for adults and half that for children.

Though Mariani was clearly a talented chemist, his real genius was as a marketer, anticipating by over a century our obsession with celebrity endorsements. He sent complimentary cases of his wine to the leading lights of his day, expecting in return only notes of acknowledgment—which, of course, he promptly published as advertisements.

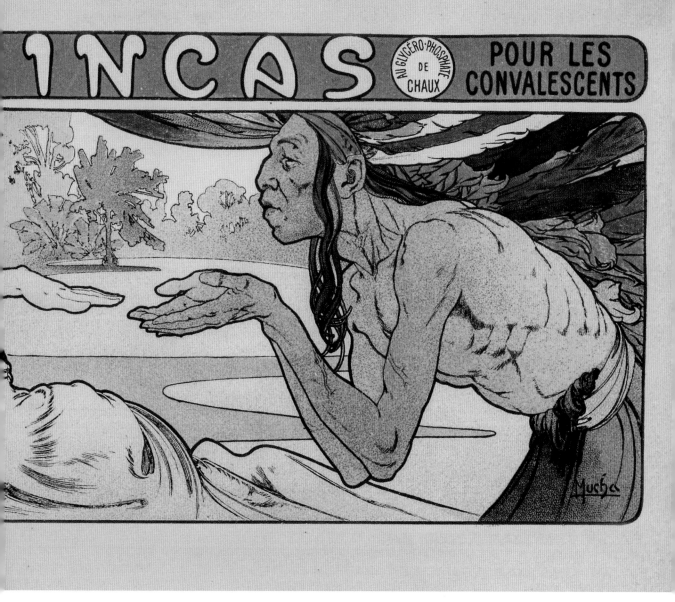

The coca based potion Vin des Incas claimed to possess many health benefits.

The list of Vin Mariani supporters is a veritable who's-who of the late nineteenth century; in fact, you can find in the halls of the British Museum thousands of testimonials about the wine, gathered in thirteen bound volumes. Among them are letters from Albert I, Prince of Monaco; King Alphonse XIII of Spain; Alexandre Dumas ("Mariani, your sweet flasks delight my mouth!"); Thomas Alva Edison; King George I of Greece; Sarah Bernhardt ("When at times unable to proceed, a few drops give me life."); Henrik Ibsen; French President Émile Loubet ("My regards to Mr. Mariani, who spreads coca."); William McKinley, President of the United States; Mozaffar ad-Din, the Shah of Persia; Auguste Rodin; Jules Verne ("Since a single bottle of Mariani's extraordinary coca wine guarantees a lifetime of a hundred years, I shall be obliged to live until the year 2700! Well, I have no objections!"); and H.G. Wells. Last, but

> *Since a single bottle of Mariani's extraordinary coca wine guarantees a lifetime of a hundred years, I shall be obliged to live until the year 2700! Well, I have no objections!*

JULES VERNE

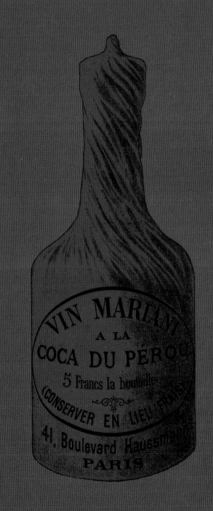

The outer wrapping of a Vin Mariani bottle, engraved in 1893. *Opposite:* A 1901 advertisement for Vin Mariani. In order to produce his drink, the French chemist Angelo Mariani combined coca leaves with red wine.

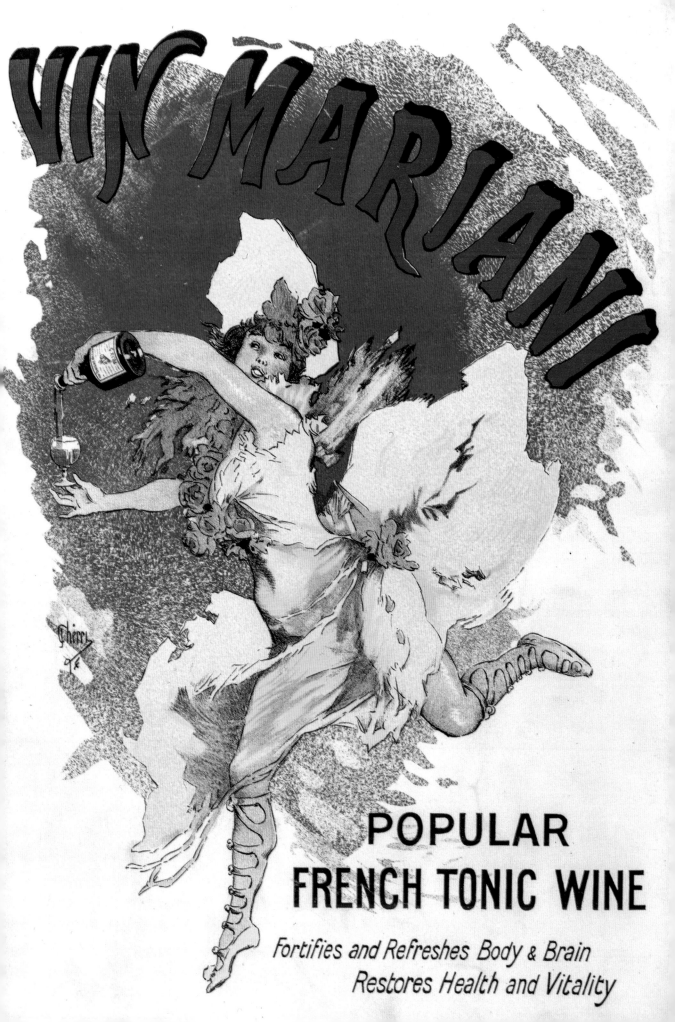

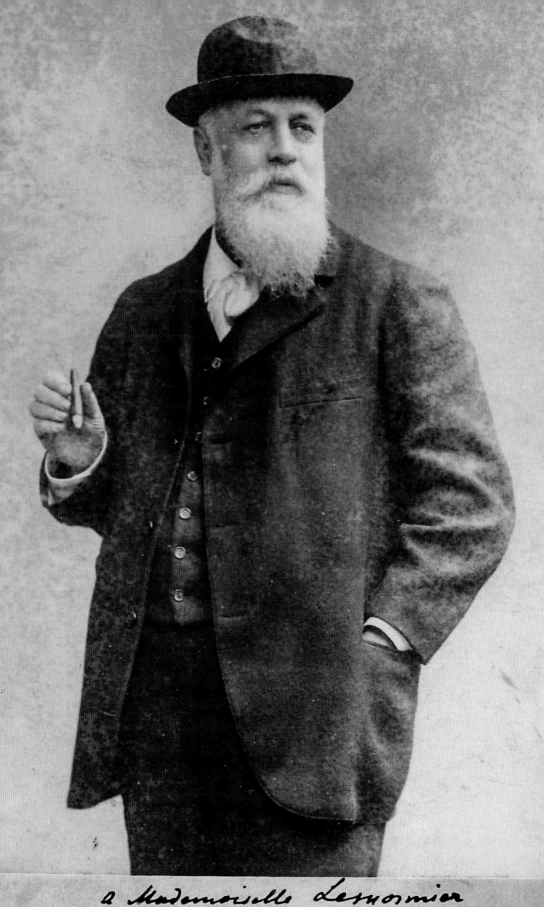

HIS HOLINESS POPE LEO XIII
AWARDS GOLD MEDAL
In Recognition of Benefits Received from

VIN MARIANI

MARIANI WINE TONIC.

FOR BODY, BRAIN AND NERVES

SPECIAL OFFER - To all who write us mentioning this paper, we send a book containing portraits and endorsements of EMPERORS, EMPRESS, PRINCES, CARDINALS, ARCHBISHOPS, and other distinguished personages.

MARIANI & CO., 52 WEST 15TH ST. NEW YORK.

FOR SALE AT ALL DRUGGISTS EVERYWHERE. AVOID SUBSTITUTES. BEWARE OF IMITATIONS.
PARIS-41 Boulevard Haussmann, LONDON-83 Mortimer St. Montreal-87 St. James St.

Vin Mariani received a gold medal from Pope Leo XIII,
who believed the tonic possessed numerous health benefits.
Opposite: Angelo Mariani developed his famous Vin Mariani in 1863.

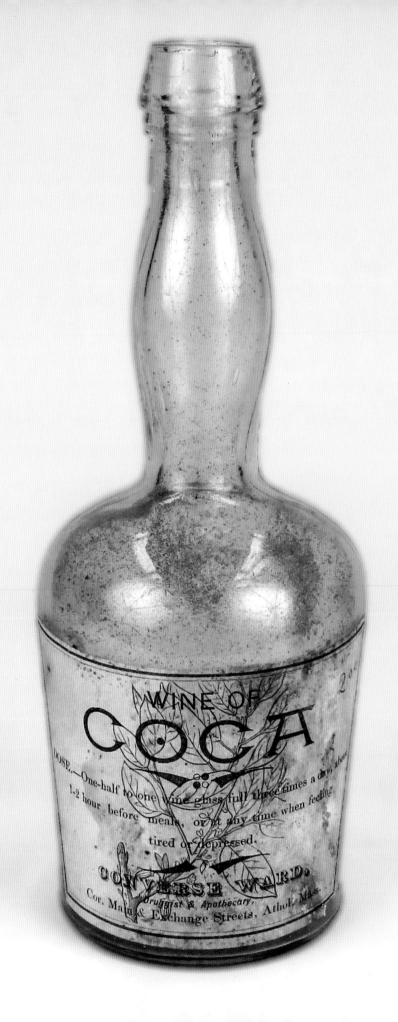

HALL'S COCA WINE

IS
NOT A PATENT MEDICINE.

It does not claim to cure "all the ills the flesh is heir to."

It is an economical and delicious preparation of the Coca Leaf, scarcely distinguishable from Port Wine in flavour. It is now generally prescribed by physicians for

MENTAL AND PHYSICAL FATIGUE

following overwork or illness, and is a most

POWERFUL NERVINE

without the evil after-effects which often follow the use of Narcotics.

IT CAN BE TAKEN BY CHILDREN AND THE MOST DELICATE PERSONS.

It is strongly recommended by *The British Medical Journal, Lancet, Medical Times, etc., etc.*

ANÆMIA,	**NEURALGIA,**
SLEEPLESSNESS,	**DEBILITY,**
INFLUENZA,	**NERVOUSNESS,**

EXTREME WEAKNESS.

A FEW GLASSES ONLY WILL PROVE ITS EFFICACY.

Give it a trial and you will never be without it, as the following medical opinions and other testimonials of **HALL'S COCA WINE** will prove.

Testimonials from well-known Medical Men.

Dr. BARRIE TAYLOR, M.B., L.R.C.P., writes :—
"I appreciate Hall's Coca Wine very much for its rapidly-stimulating action on muscle and nerve, in cases of physical and mental fatigue. I can speak confidently from experience, and testify to its worth after exertion of any kind."

Dr. PEEL RICHARDS, of Malvern, speaks of Hall's Coca Wine as follows :—
"It is the first Coca Wine I have met with deserving the name. *As a powerful nerve stimulant (without after depression) I have not known its equal.*"

Dr. ANDREWS MUNGAL, Thurso, N.B., says :—
"I used the Hall's Coca Wine myself, and consider it worthy of all you claim for it."

Dr. STURROCK, L.R.C.P., writes :—
"I gave a bottle of Hall's Coca Wine to a clergyman recovering from influenza and pneumonia. It did him a great deal of good."

Dr. A. J. MASTER, Kensington, writes :—
"I am very satisfied with the Coca Wine, and as I desire to give it an extended trial in my own family, I will thank you to send me as soon as possible a dozen bottles of it."

Dr. CROUCHER, J.P., late Mayor of Hastings, writes :—
"A patient of mine is taking your Wine with very marked benefit."

Insist on having **HALL'S.** Of Chemists and Wine Merchants, 2s. and 3s. 6d. per bottle; or post free of

STEPHEN SMITH & CO.,
BOW, LONDON.

N.B.—A tasting sample will be sent post free on receipt of name and address.

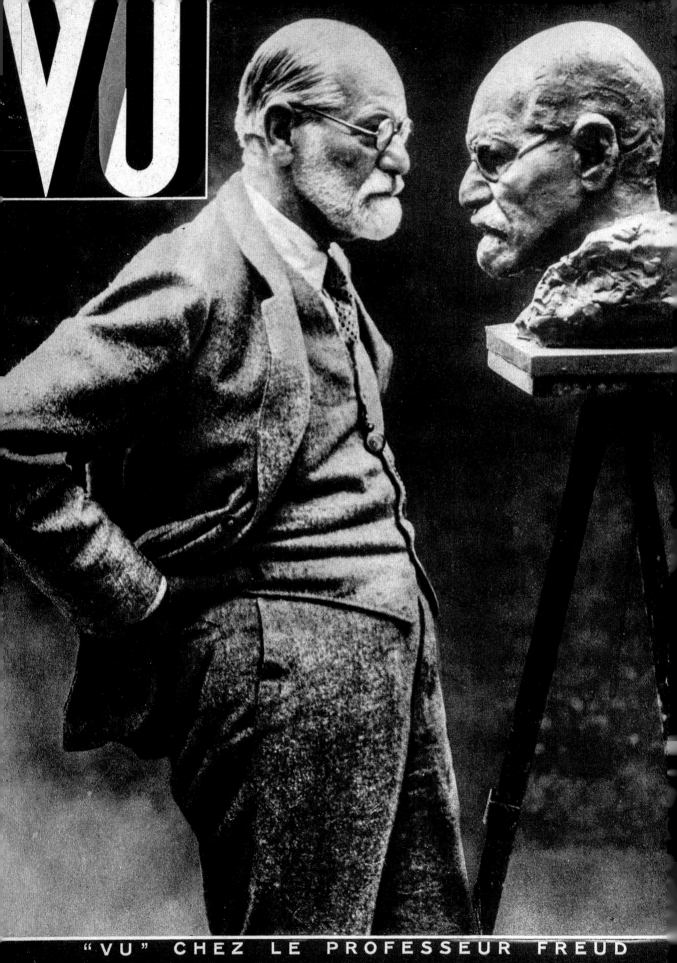

"VU" CHEZ LE PROFESSEUR FREUD

"VU" continue à visiter à travers le monde les grands de ce jour. Aujourd'hui, nous présentons à nos lecteurs le professeur Freud chez qui nous avons pu réaliser un reportage photographique du plus haut intérêt. On lira dans ce numéro l'important interview qu'a donné à notre envoyé spécial le maître de la psychanalyse. Ci-dessus, Freud devant son buste, par le sculpteur Nemon.

certainly not least, was Pope Leo XIII, who sent Mariani a gold medal and was said to carry a flask of Vin Mariani with him at all times—presumably in case sacramental wine failed to provide sufficient spiritual fortification.

Mariani's success inspired copycats in Europe and across the Atlantic—including, most notably, John Stith Pemberton, a pharmacist in Atlanta, Georgia. Pemberton had previously experimented with less-memorable and less-successful products like "Dr. Tuggle's Compound Syrup of Globe Flower," but he sensed that coca could be the key to his success. First, he created "Pemberton's French Wine Coca" and branded it as "a most wonderful invigorator of sexual organs." Ironically, neither the lascivious claim nor the coca was behind this first product's demise—instead, it was the wine itself. Atlanta passed a strict alcohol prohibition law in 1885, more than three decades before it became the law of the land across the United States. All of a sudden, Pemberton found himself operating in dry territory. Ever-resourceful, he replaced the wine in his beverage with water and syrup and kept the coca. Billed as a family-friendly "temperance drink," Coca-Cola made its official debut in 1886.

An engraving of a coca bush, 1895. *Opposite:* Sigmund Freud regards his own likeness in sculpture, 1932. *Previous pages:* (*left*) An empty bottle that once contained Wine of Coca. (*right*) A poster for Hall's Coca Wine has multiple disclaimers.

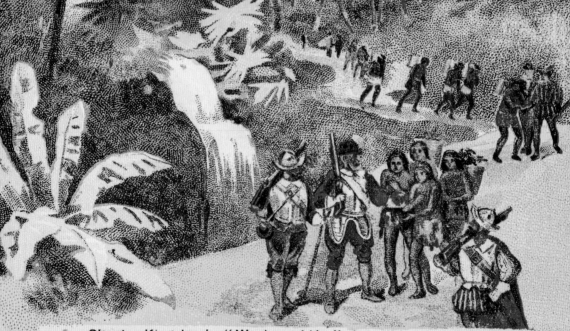

An advertisement for French Wine Coca.

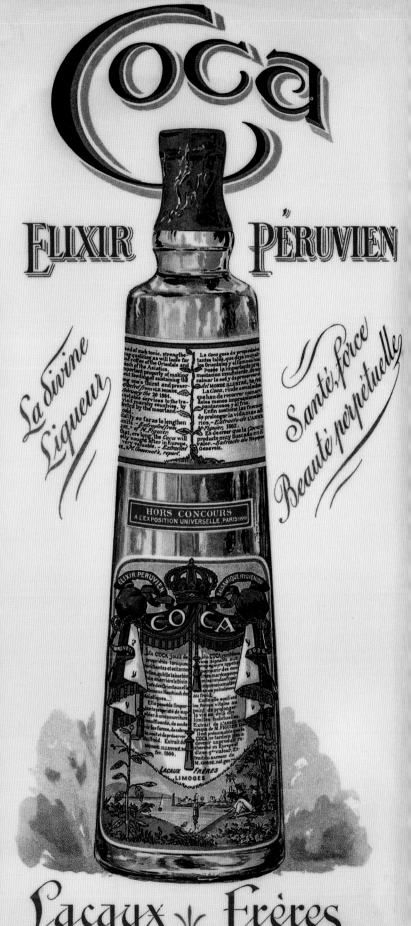

> **66** *A few minutes after taking cocaine, one experiences a sudden exhilaration and feeling of lightness. One feels a certain furriness on the lips and palate, followed by a feeling of warmth in the same areas; if one now drinks cold water, it feels warm on the lips and cold in the throat. On other occasions the predominant feeling is a rather pleasant coolness in the mouth and throat.* **99**

SIGMUND FREUD
IN "ÜBER COCA," ("ABOUT COCA") IN THE JOURNAL
CENTRALBLATT FÜR DIE GES. THERAPIE, 1884

A French poster for the beloved beverage Coca des Incas. *Previous pages:* Advertisements for Coca-Cola prior to the removal of cocaine from its formula.

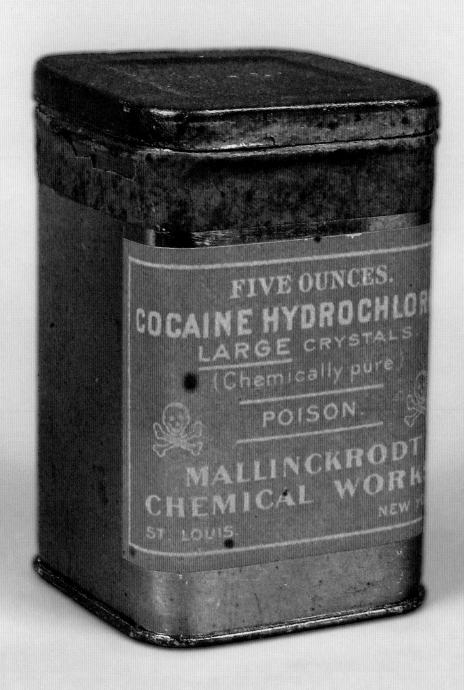

Not Quite
a Miracle Drug

Mariani and Pemberton were key protagonists in the history of cocaine, but perhaps no one contributed more to its spread and misuse than Sigmund Freud. Before becoming the father of psychoanalysis, Freud was a medical researcher in Vienna with surprisingly commonplace ambitions. He was determined to make it big, one way or another, in order to amass sufficient funds to marry his sweetheart, Martha Bernays, who lived near Hamburg. In 1884, two years after meeting her, he sent her a letter explaining his plans to experiment with cocaine, hoping it could be of use to patients suffering from heart disease and nervous exhaustion. One lucky discovery, he reasoned, would give him the means for them to finally be together.

From day one, Freud got a little too close to his work. He procured a gram of cocaine from a pharmacy and noticed it gave him a general sense of well-being. He promptly ordered more and started sharing it with friends and colleagues, as well as with his intended bride. Shortly thereafter he published an academic paper, "Über Coca" ("About Coca"), that, like Mantegazza's study twenty-five years before, described the effects of the drug in suspiciously un-rigorous terms. Freud's writing was slipshod and full of spelling mistakes, incorrect titles, and general imprecision; it spoke of the "gorgeous excitement" that cocaine provided and asserted that "no craving for the further use of cocaine appears after the first, or even after repeated taking of the drug."

Part of the problem was that, initially, coca and cocaine were assumed to be the same thing, which isn't the case. While cocaine is obviously present in coca, consider this: You need about one kilo of coca leaves to yield five grams of cocaine. This ratio can vary greatly according to coca strains and extraction methods, but you get the idea—try holding a bushel of salad between your cheeks and gums for hours on end. It didn't help that Freud and his contemporaries were also completely in the dark about the sophisticated and pernicious way in which cocaine works.

Cocaine hydrochlorate, which was used as a surface anesthetic. *Following pages, from left:* A bottle of Parke, Davis, & Co.'s Kola Compound Elixir; a bottle of Liquid Extract of Coca; a bottle of COCA: ER; a bottle of coca leaves extract.

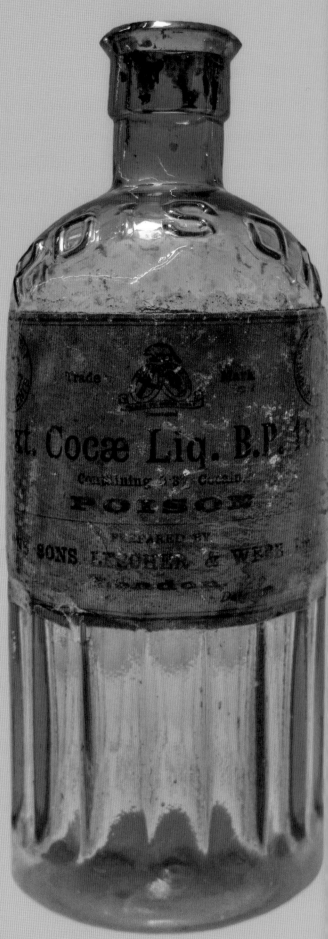

4 Fl.ozs. No. 122

ELIXIR

Kola
Compound

EACH FLUID OUNCE (28·5 c.c.) REPRESENTS:

Kola Nut..............................40 grains (2·6 gm.)
Celery Seed..........................40 grains (2·6 gm.)
Coca, B.P.C..........................40 grains (2·6 gm.)

Dose: 1 to 2 fluid drachms (4 to 8 c.c.).

CAUTION: It is dangerous to
exceed the stated dose.

PARKE, DAVIS & C?
LONDON

xt. Cocæ Liq. B.P.

Containing 3·3% Cocain

POISON

PREPARED BY

SONS LEACHER & WEBB

London

COCA. E~
Not For ~age

~nteed under The Food and
June 30, 1906. Guaranty~

FLUID EXTRACT

Coca Leaves

U. S. P. (Eighth Revision)

ASSAYED

The Leaves of Erythroxylon Coca

CONTAINS 38% OF ALCOHOL

Standard 0.5% of ether-soluble
alkaloids

A nervous excitant, its effects
resembling those of tea and coffee,
imparting to the system, under
extreme physical exertion and
fatigue, a vigor and buoyancy that
are surprising. The inhalation of
Nitrite of Amyl is recommended
to counteract the effect of this
drug.

AVERAGE DOSE.—30 mins. (1.90 c.c.)

JOHN WYETH & BROTHER

Incorporated

Manufacturing Chemists

PHILADELPH...

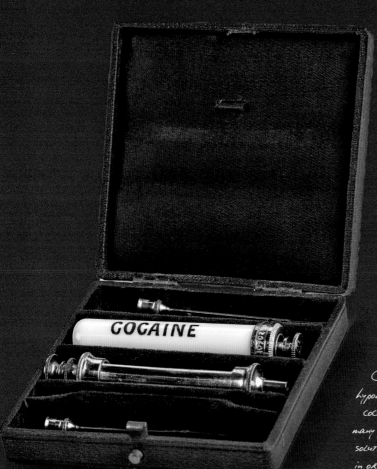

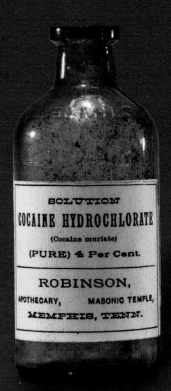

SOLUTION
COCAINE HYDROCHLORATE
(Cocaine muriate)
(PURE) 4 Per Cent.

ROBINSON,
APOTHECARY, MASONIC TEMPLE,
MEMPHIS, TENN.

Clockwise from left: A case containing a hypodermic syringe used to administer cocaine; cocaine's effectiveness as an anesthetic took many forms, including this cocaine hydrochlorate solution; registers such as this were maintained in order to keep track of customers' purchases of opium and coca products.

Opposite: The father of psychoanalysis, Sigmund Freud. *Following pages:* (*left*) An early-twentieth-century French first-aid kit.

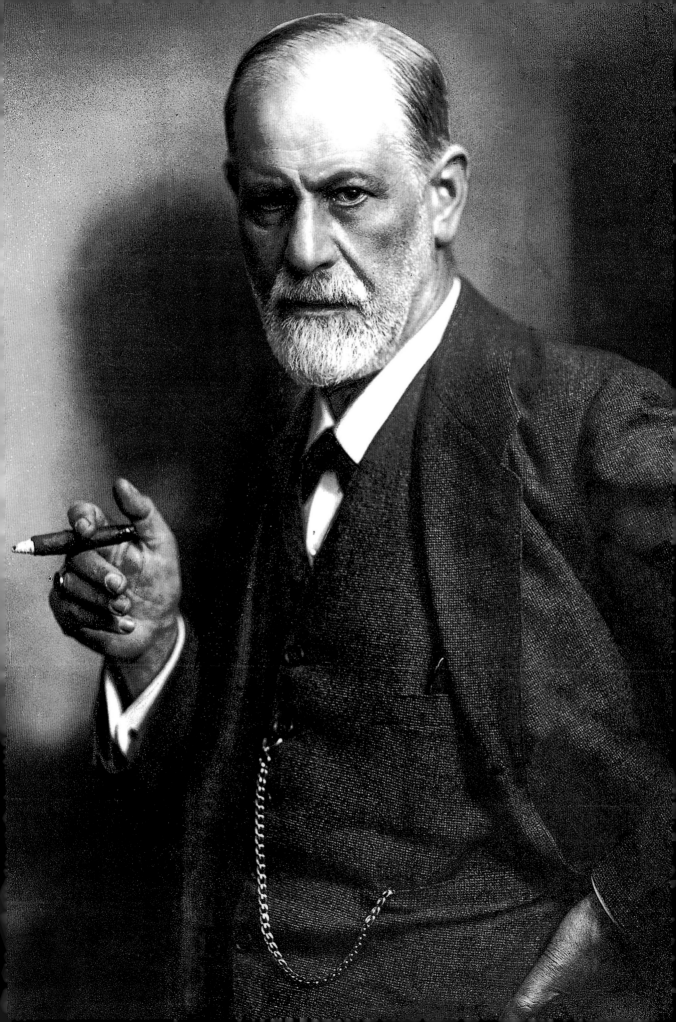

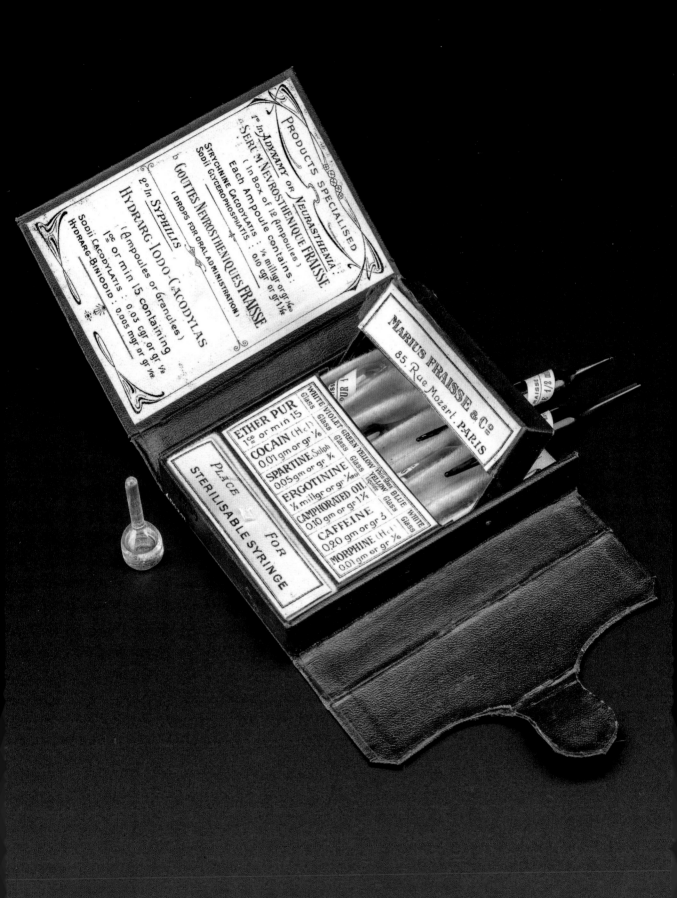

PRODUCTS SPECIALISED:

1° In **ADYNAMY** OR **NEURASTHENIA**:
a SÉRUM NÉVROSTHÉNIQUE FRAISSE
(In Box of 12 Ampoules)
Each Ampoule contains:
Strychnine Cacodylatis : ½ millgr or gr ¹⁄₁₂₀
Sodii Glycerophosphatis : 0.10 cgr or gr 1½
b GOUTTES NÉVROSTHÉNIQUES FRAISSE
(DROPS FOR ORAL ADMINISTRATION)

2° In **SYPHILIS**:
HYDRARG-IODO-CACODYLAS
(Ampoules or Granules)
1cc or min 15 containing
Sodii Cacodylatis : 0.03 cgr or gr ½
Hydrarg-Biniodid : 0.005 mgr or gr ¹⁄₁₂

MARIUS FRAISSE & Cie
85. Rue Mozart. PARIS

	WHITE Glass	VIOLET Glass	GREEN Glass	YELLOW Glass	YELLOW BLUE Glass	WHITE Glass
ÉTHER PUR 1cc or min 15						
COCAIN (HCl) 0.01 gm or gr ⅙						
SPARTINE Sulph 0.05 gm or gr ¾						
ERGOTININE ½ millgr or gr ¹⁄₁₂₀						
CAMPHORATED OIL 0.10 gm or gr 1½						
CAFFÉINE 0.20 gm or gr 3						
MORPHINE (HCl) 0.01 gm or gr ⅙						

PLACE FOR STERILISABLE SYRINGE

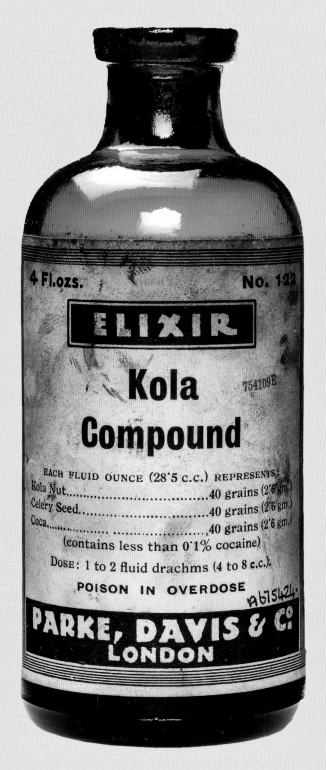

Parke, Davis, & Co.'s (now Parke-Davis) Kola compound elixir contained kola nuts, which were later used in the first cola soft drinks.

TO BE KEPT IN A DRY PLACE.

THE
PATENT
MEDICATED
GELATINE LAMELS,
FOR INTERNAL USE.
SAVORY & MOORE, L.TD

Chemists to the King.

143, NEW BOND STREET,
29, CHAPEL ST. BELGRAVE SQUARE & 1, LANCASTER GATE,
LONDON.

COCAINE
1/10th grain (6.5 Mgm.)
POISON.

Savory & Moore's Patent Medicated Gelatine Lamels were filled with cocaine, their active ingredient.

It all starts with—bear with us here—the mesolimbic dopamine system. Appropriately known as the reward pathway of the brain, it responds to such stimuli as food, sex, and, well, drugs. Dopamine is the compound that transmits pleasurable sensations through the body and propels us to seek out more of it. In terms of evolution, the system ensures that we have a healthy drive toward activities that benefit the human species, such as reproduction and nourishment, but in the interest of avoiding the troubles that come with having too much of a good thing, our brains also developed safeguards and limitations.

When you slip into a hot bath, for example, a release of dopamine lets you know that you're engaging in a pleasant activity. That release, though, is eventually swept up and reserved for the next stimulus, which explains why most of us don't permanently reside in bathtubs. It's also the reason why, after sex, cuddles and a nap—or beating a hasty retreat, depending on the circumstances—are the common aftermath: As the dopamine is recalled, the sexual urge recedes. Cocaine hijacks this mechanism by blocking dopamine reuptake and allowing it to float around for as long as the drug is consumed. This fuels the addiction—the desire to take more in a futile attempt to stave off the inevitable absence of dopamine. Freud definitely experienced withdrawal, but he failed to, or refused to, connect the dots.

TO BE KEPT IN A DRY PLACE.

THE
PATENT
MEDICATED
GELATINE LAMELS,
FOR INTERNAL USE.

SAVORY & MOORE, Lᵀᴰ

Chemists to the King.

143, NEW BOND STREET,
29, CHAPEL ST. BELGRAVE SQUARE & 1, LANCASTER GATE,
LONDON.

COCA EXTRACT
½ grain (0.03 Gm.)

These gelatin squares were manufactured between 1915 and 1919.

When Freud and a colleague, Carl Koller, dosed themselves, Freud noted that cocaine acted as an anesthetic, as it numbed their lips, but there, too, he missed the bigger picture. On the other hand, Koller, an ophthalmologist, paid keen attention. Like everyone in his field, Koller had been struggling with how to perform eye surgeries without anesthetics. At the time, local anesthetics hadn't yet been developed, and most surgical procedures for the eye required patients to be awake so they could tell the doctor what they could or couldn't see, or so they could blink or move their eyes on command. Only a patient desperate to avoid blindness from, say, cataracts, or who otherwise had no choice would consent to being strapped to a chair and immobilized as best as possible while a surgeon sliced into his eyeballs. Koller wondered: If cocaine numbed his lips, could it also numb his patients' eyes?

Sure enough, it did. Unbeknownst to Koller, his laudable discovery was nothing new: The Incas had used coca as an analgesic for centuries. In Ancient Peru, it offered a measure of relief during trepanations, rudimentary surgical procedures in which small pieces of patients' skulls were removed to ease pressure in the brain caused by traumatic head injuries (usually combat-related).

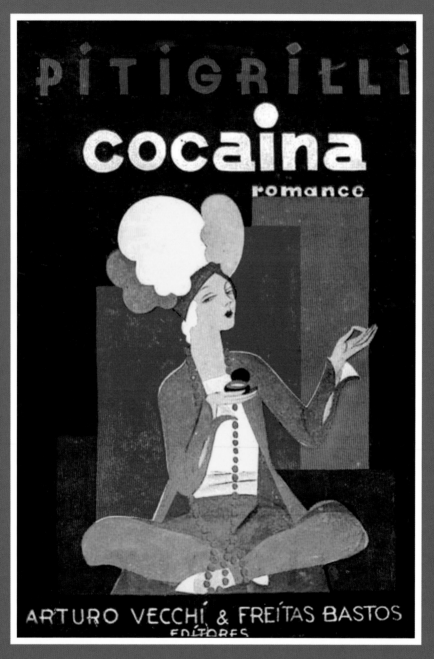

A Portuguese edition of Italian writer Pitigrilli's "Cocaina," 1921. Opposite: Commonly used in indigenous cultures, poporos are containers made to hold lime, which is placed in the mouth while the user chews on coca leaves.

Cocaïn.hydr.

opellssd.

This stamp is not transferable on change of owner- ship of business.

Upon change of ownership, control, address, or location notify your District Director immediately.

WARR, RICHARD ALEXANDER
2601 N WHITTIER ST
ST LOUIS MO

Class of tax	
4	
Period beginning July 1, 1959 or:	Amount of tax

ISSUED BY DISTRICT DIRECTOR OF INTERNAL

SPECIAL T

OPIUM, COCA LEAVE

KEEP THIS S

M.D.

LOS ANGELES

~~ST. LOUIS~~

Registration Number	
26358 ~~7003~~	
RETURN NUMBER 3-6 441869	

Additions	Total
	1.00

ST LOUIS

110689

This is a tax receipt - - not a license

EXPIRES JUNE 30, 1960

:VENUE _____

AX STAMP

INTERNAL REVENUE

S, MARIHUANA, ETC.

AMP POSTED

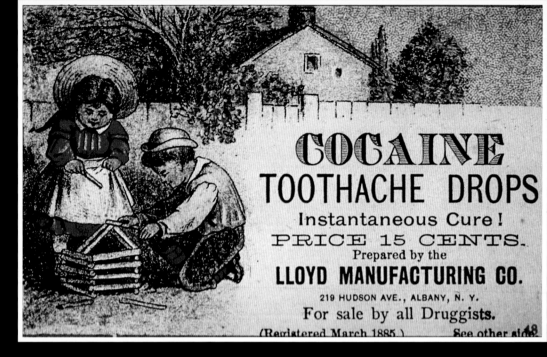

An advertisement for Cocaine Toothache Drops, 1890.
Opposite: Forced March tablets combined both kola nuts and coca leaves to "allay hunger and prolong the power of endurance."

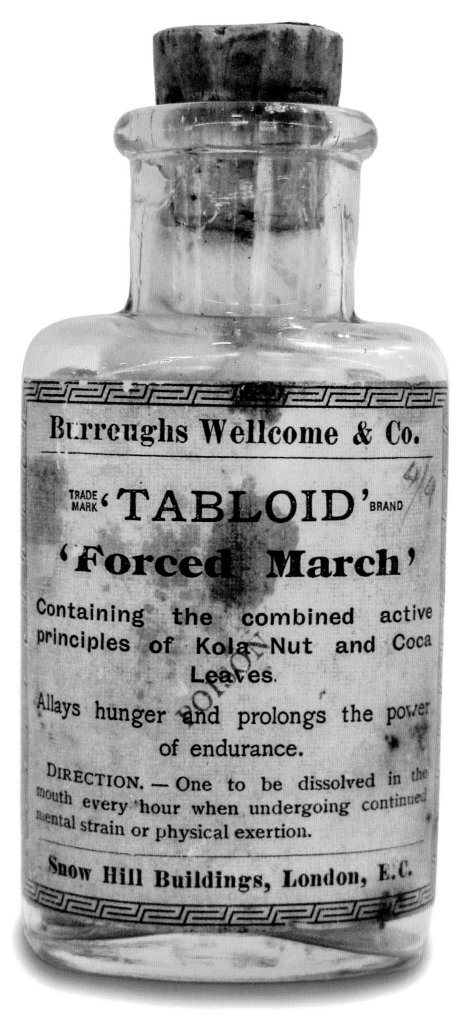

Burroughs Wellcome & Co.

TRADE MARK 'TABLOID' BRAND

'Forced March'

Containing the combined active principles of Kola Nut and Coca Leaves.

Allays hunger and prolongs the power of endurance.

DIRECTION. — One to be dissolved in the mouth every hour when undergoing continued mental strain or physical exertion.

Snow Hill Buildings, London, E.C.

Once Koller presented his findings, he was lavished with all the celebrity and acclaim that Freud had so desperately chased. In one fell swoop, a major surgical problem had been solved, and cocaine became big news within the medical community. Determined to find new uses for it, Freud and other doctors liberally prescribed it for maladies as diverse as depression, stomach ailments, menstrual cramps, and dental and throat afflictions. Not surprisingly, physicians and dentists eager to keep up with the latest medical developments became the first cocaine addicts. Next came their patients and, in many cases, their spouses and friends followed.

Perhaps the most counterproductive medical use for cocaine was its application as a purported cure for opium and heroin addiction. By the end of the nineteenth century, opiate addiction had become a huge problem, especially in the United States. During the American Civil War, opiates were the only recourse for managing wounded soldiers' pain. Once the war ended, those patients were hooked. They either had to go cold turkey or procure the drugs by whatever means necessary. John Stith Pemberton was just such a veteran—he had suffered a saber wound to the chest and subsequently become addicted to morphine. Thus, he had a strong personal incentive to experiment with opiate-free painkillers.

In retrospect, it's easy to see why treating opiate addictions with cocaine might have made sense; after all, opiates are downers and cocaine is an upper. It's also worth noting that drug manufacturers like Merck and Parke-Davis had plenty to gain by experimenting with treatments for people addicted to the products they sold, which included opiates and cocaine—as long as the cures involved using more and different products they manufactured.

Eventually, it became obvious that even in the best of cases, patients were merely trading one addiction for another. Most toggled back and forth between heroin or morphine and cocaine, and there was little doubt that the double-addiction process could go both ways. William Halstead, a founding professor at Johns Hopkins Hospital who was later recognized as the father of modern surgery, started out with a cocaine addiction, turned to morphine to ease his withdrawal pains when he tried to quit, and quickly became addicted to downers instead.

The problem only grew from there: Once cocaine gained mass notoriety, pharmaceutical companies ramped up production, and its price dropped dramatically. Soon, it was everywhere. In fact, anyone flicking through a newspaper or magazine in the late nineteenth century would have been forgiven for thinking that scientists had somehow stumbled upon a magical elixir.

A poster for "Cocaine Candy," a popular treat that contained doses of cocaine.

1 PACKAGE (of 6 ampuls)

FSN 6505-114-5025
STERILE
COCAINE HYDROCHLORIDE, U. S. P.
0.5 Gm. per Ampul

WARNING: May be habit forming.

POISON **A**

CAUTION: This is a dangerous drug. To be used only under strict medical supervision. FOR TOPICAL USE ONLY

CAUTION: Federal law prohibits dispensing without prescription. Made in U. S. A. See Enclosed Circular
Control No. 13199B

THE VITARINE CO., INC., New York, N. Y., U. S. A.

Above: A sterile package of cocaine hydro-chloride. Below: A glass vial containing a potentially deadly combination of atropine and cocaine, which served as a medical muscle relaxant. If used incorrectly, the compound can be lethal.

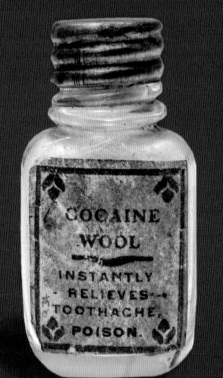

Above: Another cocaine-based tooth product, Cocaine Wool, was intended to be inserted directly into cavities in teeth to relieve toothaches.

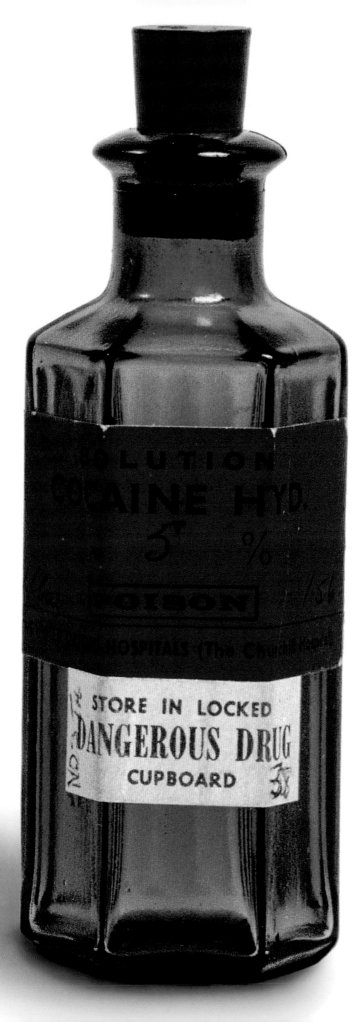

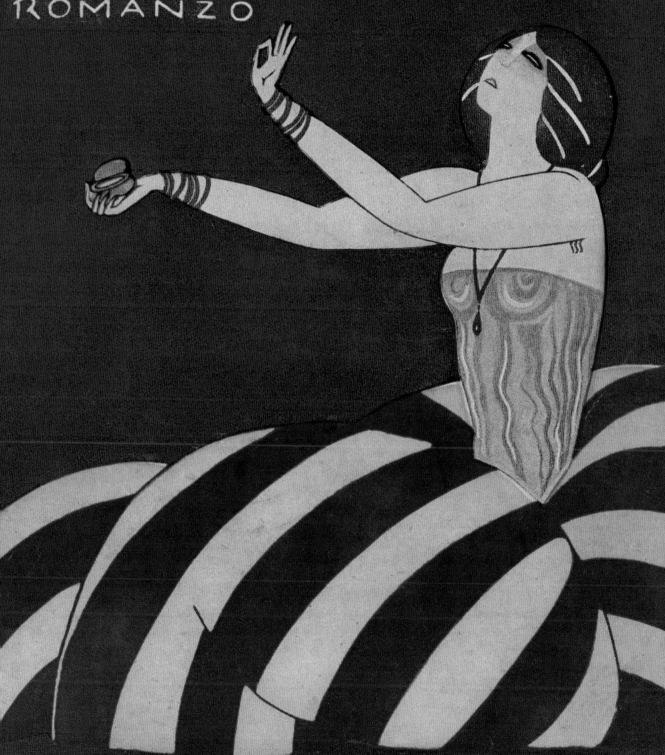

PITIGRILLI
COCAINA

ROMANZO

CASA EDITRICE SONZOGNO MILANO

"This 'Intellectual Beverage' and nerve stimulant," read one splashy advertisement, "makes not only a delicious, exhilarating, refreshing and invigorating beverage, but a valuable brain tonic, and a cure for all nervous affections—headache, neuralgia, hysteria, melancholy. You will be surprised how quickly it will ease the tired brain—soothe the rattled nerves and restore wasted energy to both mind and body. It enables the entire system to readily cope with the strain of any excessive demands made upon it."

Another ad, this one for tablets, promised "a benefit to elocutionists, public speakers and singers...strengthening the vocal cords and preventing hoarseness." Yet another urged mothers to give drops of a mysterious potion to their children—"Instantaneous Cure!"—to soothe teething pains and other pesky afflictions. Sadly, there's no record of whether tots eagerly anticipated dental afflictions once they'd been given a taste of Cocaine Toothache Drops, sold by Lloyd Manufacturing Co. of Albany, New York.

One can see how—initially, at least—Allen's Cocaine Tablets might have been of use to tongue-tied public speakers, though we will never know whether said orators went on to slur their words while regaling audiences with lightning-fast, pointless anecdotes only they found amusing. We do know, however, that Coca-Cola, the "intellectual beverage and nerve stimulant" that was so beneficial to one's constitution, is still with us today, albeit in a significantly modified version.

The truth is that cocaine's only real medical use was as a topical analgesic. Once Novocain and other anesthetics had been developed, it wasn't even useful for that purpose. The so-called miracle drug could make you feel good for a while—its recreational use increased fivefold in the 1880s and 1890s—but it didn't really cure anything. Instead, it was creating a substantial population of addicts, and once cocaine's dangers became apparent, popular opinion turned quickly.

In the American South, cocaine was even opportunistically used as an excuse for racism. Originally, Coca-Cola was sold only to well-to-do whites in segregated soda parlors, but after it was bottled and finally available to minorities for a pittance, Southern newspapers spread the myth of black criminal "cocaine fiends" who gained supernatural strength. In fact, white fearmongering is one of the reasons Coca-Cola stopped utilizing cocaine in 1903—a little over a decade before the drug was officially banned in the United States. (Nonetheless, coca leaves stripped of their alkaloid content remained in the recipe and are still very much a part of Coca-Cola today. Thousands of kilograms of coca leaves are imported to the United States and processed for the production of Coca-Cola every year.)

A German poster from the 1920s demonstrates just how much cocaine usage was in style. *Previous pages:* (*left*) A bottle containing a solution of cocaine hydrochloride, 1938. (*right*) An alternative cover for Pitigrilli's *Cocaina*.

66 *Hydrochlorate of cocaine is at the present moment attracting an amount of attention rarely accorded to any therapeutic agent not of the very first rank. It may be fairly said that the news of the introduction of a new local anesthetic has been hailed with universal satisfaction.* **99**

AN 1884 EDITORIAL IN THE *BRITISH MEDICAL JOURNAL,* QUOTED IN
COCAINE: AN UNAUTHORIZED BIOGRAPHY BY DOMINIC STREATFEILD

Extracts of the drug were even used in products like this tooth wash sold by Joseph Burnett & Co.

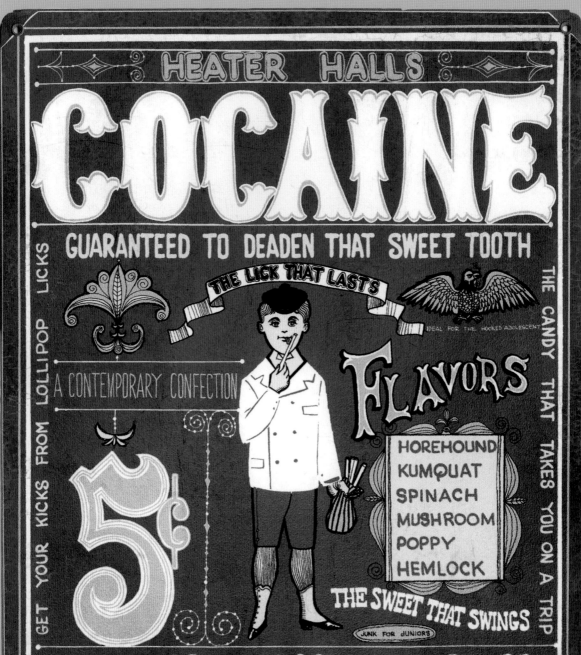

Used for medicinal purposes, Allenbury's Throat Pastilles contained both menthol and cocaine. Opposite: Cocaine Candy was sold in a variety of flavors, including spinach and mushroom. The snacks were intended to reduce children's cravings for sugar.

Following pages: (*left*) A front-cover illustration entitled "The Hiding Place of the Cocaine Addict" for the October 16, 1924 edition of *Sciences et Voyages*. (*right*) The illustration "Cocaine!....One-Step," published by A. Forlivesi, 1927.

N° 268

Soyez de votre temps
en lisant

75 cent.

Sciences et Voyages

LA CACHETTE DE LA COCAÏNOMANE

Dans ce numéro : Un article sur la cocaïne et les cocaïnomanes

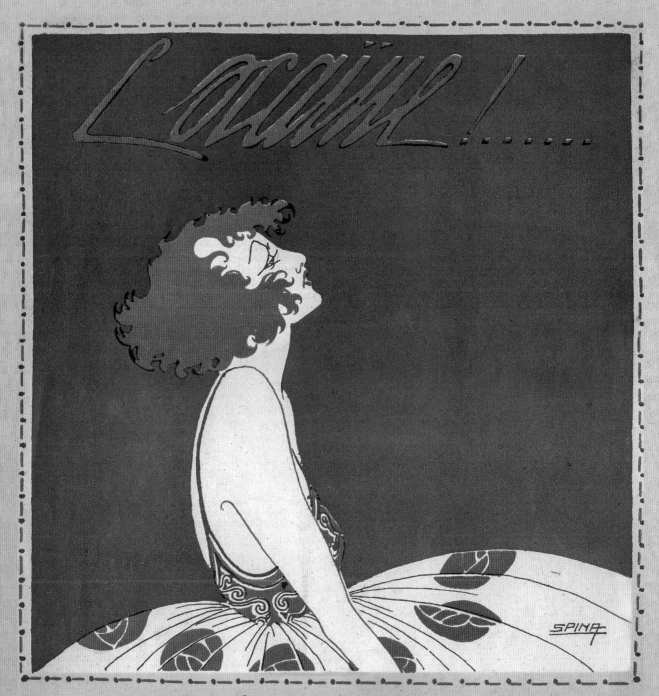

One-step

Paroles de BIBI Musique de P. Paul

CASA EDITRICE DI MUSICA
A. FORLIVESI & C.
2, Via Roma - FIRENZE - Via Roma, 2
Deposito a norma di legge e dei trattati internazionali
Proprietà per tutti i paesi

Nº 10919

Net Fr. 2.—

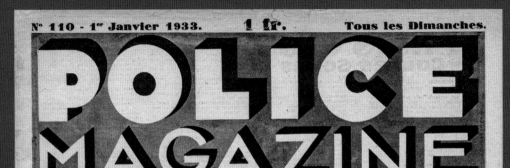

POLICE MAGAZINE

LES POURVOYEURS DE COCO

Lire, pages 8 et 9, nos révélations troublantes sur le trafic de la cocaïne à Paris et l'existence des odieux pourvoyeurs de drogue. La jeune femme ci-dessus prépare un paquet de coco qu'elle enfermera dans cet innocent bouquet, afin de dépister les vigilants inspecteurs de la brigade mondaine. (S. G. P.)

On New Year's Day 1933, "Police Magazine" published this illustration titled "Supplies of Cocaine" on its front cover.

Opposite A poster by artist Mihály Biró for the German silent film *Laster der Menschheit*, 1927.

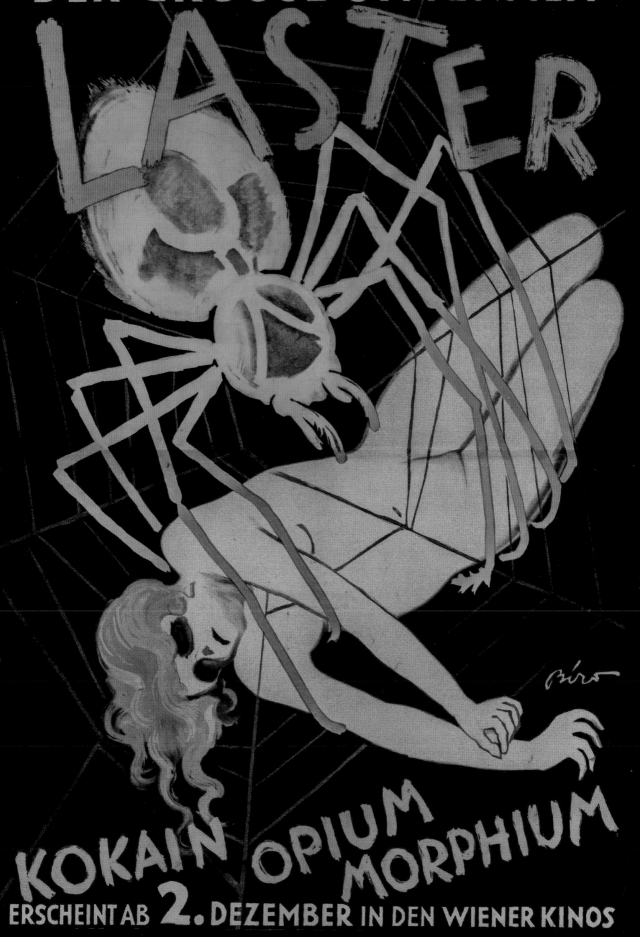

A shift in the societal perception of cocaine can be seen clearly in the literature and popular culture of the turn of the twentieth century. Sherlock Holmes, the famous detective created by Sir Arthur Conan Doyle in the 1880s, was perfectly cavalier about his drug use—reflecting the prevailing attitude of the time. In the novel *The Sign of the Four*, Holmes casually injects himself with it and later states, "It is cocaine…a seven percent solution. Would you care to try it?"

Conan Doyle's contemporary Robert Louis Stevenson once wrote 60,000 words during a six-day binge that occurred while he was infirm and self-medicating. The resulting book, *The Strange Case of Dr. Jekyll and Mr. Hyde*, was about an unassuming man who takes a drug that transforms him into a raging beast; of course, it was an immediate success. (Stephen King, another prolific and successful author with a penchant for horror, admitted to a massive cocaine addiction a century later.)

By contrast, mentions of cocaine in literature from the 1920s were invariably negative—in her novels, Agatha Christie alluded to dissolute addicts who snorted away fortunes. French novelist Marcel Proust, who had once admired the *fin de siècle* Parisian dandy Robert de Montesquiou, a man who was hardly shy about his cocaine use, wrote about degenerates getting high in a homosexual brothel. Although Aleister Crowley wrote that "happiness lies within one's self, and the way to dig it out is cocaine" in *Diary of a Drug Fiend*, published in 1922, the book is also filled with harrowing scenes of withdrawal and attempted suicides. *Cocaine*, a British film also released in 1922, presented the drug as dangerous and immoral. Around that time, the word "dope," which had previously been used exclusively as a synonym for drugs, began to be used in reference to a person with diminished mental capabilities.

Cocaine was officially banned in the United States in 1914 and in Great Britain in 1920. The simple act of passing the legislation was surprisingly effective: Because the

The Jim Kandy record featuring the song "Cocaine Blues," released in 1965. *Following pages*: (*left*) A cover of the musical score for the song "La Coco," 1910. (*right*) A poster for the 1922 film *Cocaine* reads "How Girls Become 'Dope Fiends'!!"

K·ARK
RECORDS

45 RPM
Peer International
BMI
Time 2:28

Record No.
637-A
Produced by
John Capps

COCAINE BLUES
(Jordan)

JIM KANDY
728 16th Ave. So. Nashville, Tennessee

LA COCO...

Chantée par **TURCY**
ET PAR
Emma LIEBEL

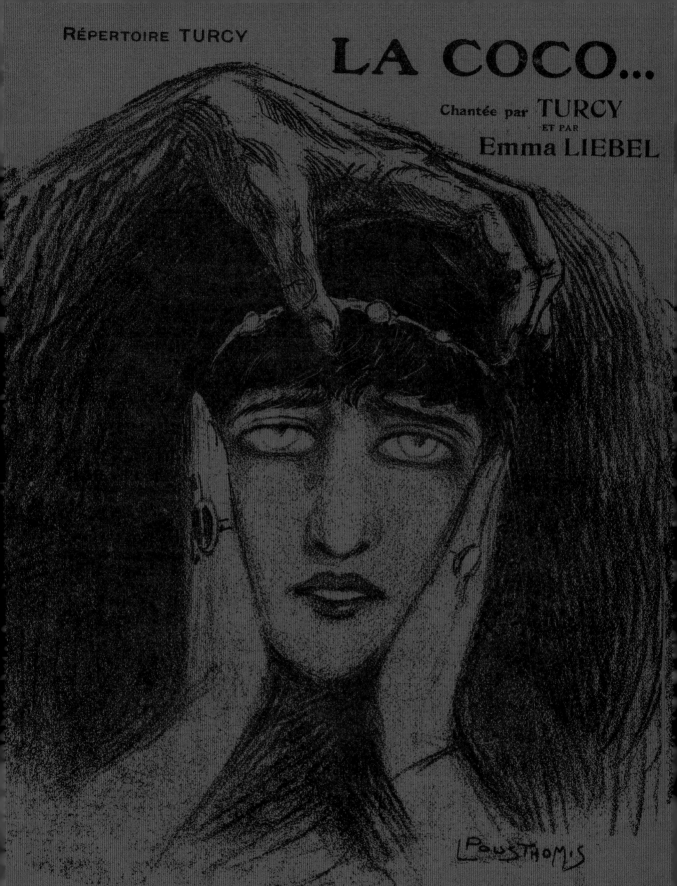

PAROLES DE
Bouchaud (dit DUFLEUVE)

MUSIQUE DE
G. OUVRARD fils

CHANT SEUL: 1. NET

PIANO ET CHANT: 5. NET

Paris, MARCEL LABBÉ, Éditeur, 20, Rue du Croissant (II^{me})
Tous droits d'exécution, de reproduction, de traduction et d'arrangements réservés pour tous pays, y compris la Suède, la Norvège et le Danemark

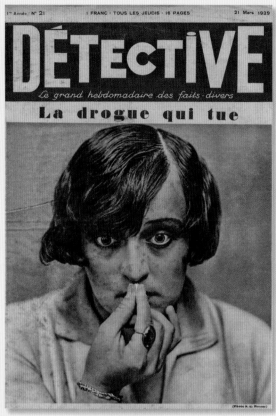

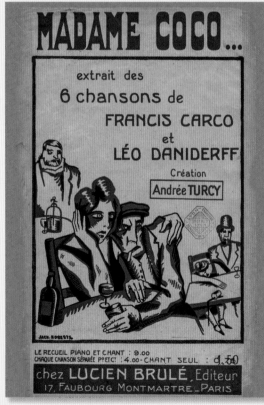

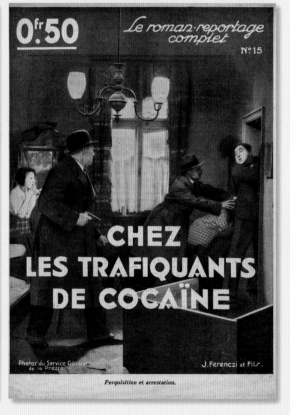

Clockwise from left: An illustration for *Cocaine* by artist Pierre Sorel, 1920; a cover illustration entitled "The Drug That Kills," for *Detective,* 1929; the illustration "Chez les Trafiquants de Cocaïne" by Guy de Téramond, 1932; an illustration cover of the musical score for the song "Madame Coco," 1924. *Opposite:* A copy of Aleister Crowley's *The Diary of a Drug Fiend.*

The Diary
of a
Drug Fiend

By Aleister Crowley

substance had been manufactured by legitimate companies, they were forced to quickly come into compliance. And once they stopped selling it, no comparable underground operation existed to take their place. Cocaine was still a relatively new product, and it was exceedingly difficult for a layperson to produce. Coca was grown almost exclusively in South America, and large quantities of its leaves were necessary to manufacture cocaine.

Suddenly, after being sold in pharmacies all over the United States and Europe (and over the counter at Harrod's, the famed London department store), cocaine became a prohibitively expensive vice available only to a select few. It always maintained a toehold in Hollywood; the actress Tallulah Bankhead once famously quipped, "Cocaine habit-forming? Of course not. I ought to know. I've been using it for years." Cole Porter alluded to it in his famous song "I Get a Kick Out of You," which originally included the line "some get a kick from cocaine."

In Europe, cocaine and opium each remained a powerful draw for bohemian artists, royals, and intellectuals throughout the Roaring Twenties and early 1930s. (The British royal family breathed a collective sigh of relief when, in 1934, the Duke of Kent married Princess Marina of Greece and Denmark rather than Kiki Preston, a decidedly less-suitable contender who was known among high society as "the girl with the silver syringe.") Toward the end of his life, Adolf Hitler augmented his insalubrious regime of daytime amphetamines and evening sedatives with cocaine infusions. Malcolm X consumed it in the 1940s, and friends of the Italian industrialist and playboy Gianni Agnelli have suggested that when he slammed his Ferrari into the back of a truck in 1952, shattering his leg, he wasn't just driving very fast; he was also very high.

Yet these are all notable exceptions to the rule. For the most part, cocaine simply was unavailable from the 1930s to the 1960s. Any serious illegal traffic that might have flourished after its criminalization was severely disrupted by World War II, which shut down transportation routes all over the world and focused everyone's attention on rather more pressing matters. Records from the 1940s, 1950s, and early 1960s reveal a precipitous decline in cocaine-related arrests, to the point where they are almost statistically insignificant. Marijuana, hashish, amphetamines, psychedelics, and heroin all had a strong presence in different places and at different points in time during the mid-twentieth century, but, for all intents and purposes, cocaine vanished.

Until, all of a sudden, it was everywhere.

A film poster for *Cocaine: The Thrill That Kills,* 1940.

COCAINE

pitigrilli

COCAINE

ALEISTER CROWLEY

> *Cocaine habit-forming?*
> *Of course not. I ought to know.*
> *I've been using it for years.*

TALLULAH BANKHEAD

A poster for Louis Le Gouriadec's *La Splendide,* illustrated by René Gaillard. 1926. *Previous pages:* (*left*) A paperback English translation of Pitigrilli's *Cocaina* printed in 1974. (*right*) Aleister Crowley's essay "Cocaine" was reprinted in 1973 for the first time since its original 1917 publication date.

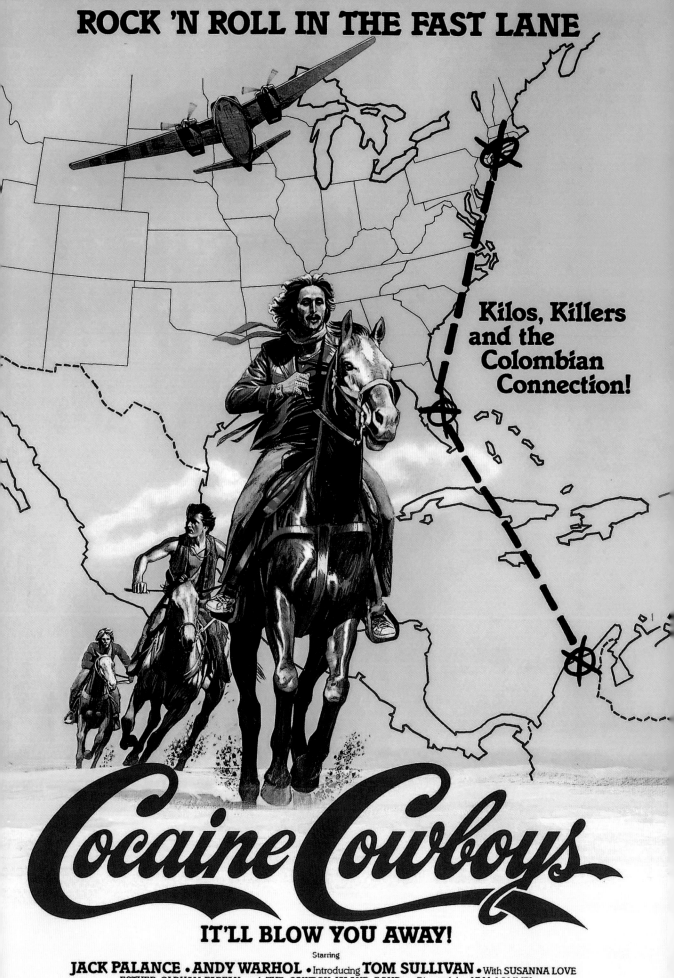

The Bigger the Party,
the Harder the Hangover

By the time *Annie Hall* came out, in 1977, Woody Allen was already late to the game. After a long absence, cocaine had dramatically exploded into the mainstream—the result of an almost-perfect storm of favorable conditions. Amphetamines were widespread in the 1950s and 1960s—as films like *Valley of the Dolls* made abundantly clear—but they were outlawed following a rash of overdose deaths, leaving the market for uppers wide open. In South America, coca crops had been as prolific as ever, and smugglers dealing in marijuana and all sorts of other contraband established international routes that could be used for any product.

Cocaine was unique in that traffickers could bank profits of about 1,000 percent—an irresistible lure in underdeveloped countries. Cubans and Colombians flocked to the United States and established communities in American cities that could facilitate exchanges with those countries. Finally, the popularization of inexpensive air travel—the beginning of globalization—made transportation easier than ever before, and detection by law enforcement became an ever-shifting game of cat and mouse.

In 1970, *Rolling Stone* named cocaine the "drug of the year." Shortly thereafter, *Newsweek* ran an article titled "It's the Real Thing" that quoted a university student as saying that "orgasms go better with coke." In 1974, *The New York Times* followed up with "Cocaine: the Champagne of Drugs," which observed that "a Who's Who of Hollywood and Hollywood-on-the-Hudson that includes actors, models, athletes, artists, jazz musicians, designers and ad men" were all heedlessly powdering their noses. "In many of their soirees," the article explained, "an after-dinner sniff of the fine white powder—either from a bejeweled coke spoon held to the nostril or through a tightly rolled banknote, the higher the denomination the better—is as common as a snifter of brandy."

This was confirmed by certain magazine ads that brought to mind those of a century prior that endorsed, say, Ryno's Hay Fever and Catarrh Remedy, which was 99.95 percent pure cocaine and recommended for use "two to ten times a day,

A poster for the 1979 release *Cocaine Cowboys*, a film about cocaine-dealing members of a rock band and their encounters with the American Mafia.

LES PARADIS ARTIFICIELS : LA FEMME EN PROIE A LA COCAÏNE

Composition de BONNOTTE.

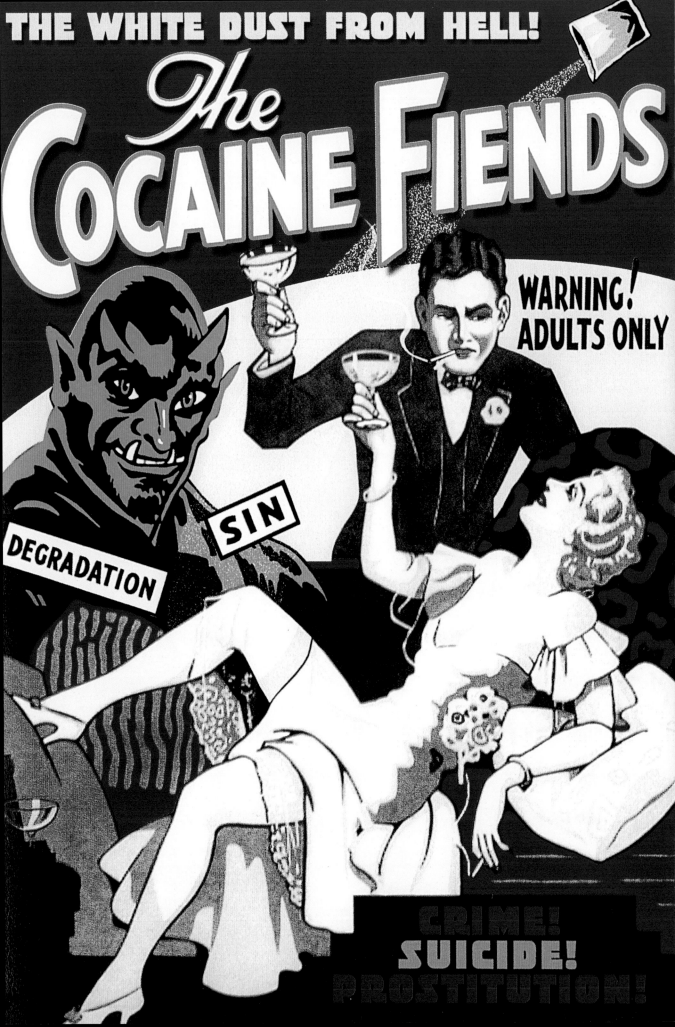

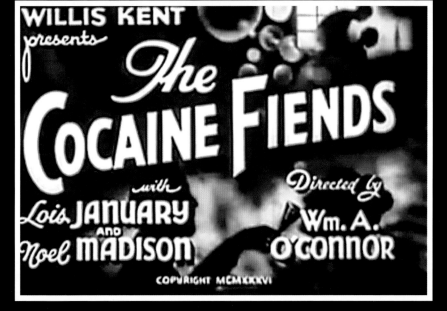

In "Cocaine Fiends", originally released as "The Pace That Kills,"
the character Jane Bradford becomes involved with a drug
dealer—and consequently becomes addicted to cocaine.

An alternate poster for the film *Cocaine Fiends. Previous pages:* (*left*) Adolf Hitler's German-translation copy of the Italian
caina by Pitigrilli. (*right*) The illustration "Artificial Paradises: A Woman Racked by Cocaine," 1933.

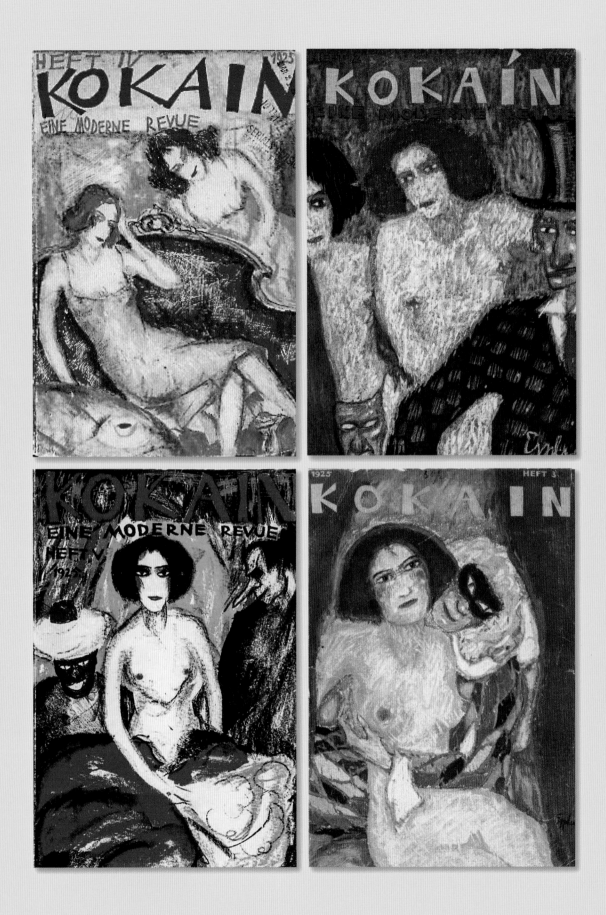

Only five issues were published of the literary journal *Kokain Eine Moderne Revue*. The journal was printed in Vienna between 1915 and 1925. *Opposite:* The title page for the musical score of *Kokain*, 1921.

KOKAIN

VALSE BOSTON
VON

EUG. HERB. DARRAS

...AUL FISCHER Musikalienhandlung

KLAVIER.
SALON-ORCH.

or oftener [sic] if really necessary." The caveat: This time around, the ads focused strictly on paraphernalia.

Snowmill, a contraption designed to crush certain unspecified crystals to in effect "make your snow grow," could be ordered with a matching mirrored tray that was "functional, attractive, and easy to pass around." The Frost-Ade Kit, a custom-made suede wallet with "individually polished stone, amber glass vial & straw, blade, a stash pocket and an extra pocket for your favorite spoon," was designed for "truly exquisite snorting." For $179.50 ("less than the price of 2 grams"), you could purchase the Höt Böx, an at-home testing kit that would allow you to "identify, describe, and separate common adulterants as cuts for certain crystalline materials." Most alarming of all was the "Gasper," a hollow tube with a pump that allowed users to blow powdery substances directly into the lungs, bypassing all "delicate nasal and sinus membranes."

That these ads were legal seems shocking now, in a time when even tobacco and liquor publicity is frowned on. But even more astonishing was that because cocaine had been out of sight for so long, most of its dangers had been forgotten. *Newsweek* quoted the deputy director of Chicago's Bureau of Narcotics as saying that "you get a good high with coke and you don't get hooked."

The New York Times acknowledged that virtually no studies on the effects of cocaine on human beings had been conducted since the days of Freud, yet it asserted that "for its devotees, cocaine epitomizes the best of the drug culture—which is to say, a good high achieved without the forbiddingly dangerous needle and addiction of heroin." The article added that "the drug is not addicting, at least in the physiological sense. For much the same reason, users don't feel they are forced to commit crimes to support their habit; many cocaine users simply drop the habit when the money runs out." The story did point out—perplexingly, and without any significant follow-up—that rats taught to push a lever for a reward did so up to 250 times for caffeine, 4,000 times for heroin, and 10,000 times for cocaine. (In other studies, cocaine-addled rats simply pushed the lever until they died.)

The simple fact is that after the ultra-uptight 1950s and the social upheavals of the 1960s, people were ready to have a good time, and cocaine, with its cosmopolitan allure, fit the bill. Hedonism had become, at least in certain circles, synonymous with liberation. A young, curious generation was coming of age, the Pill had just been invented, and AIDS was not yet on the horizon. The 1970s also marked the beginning of an era in which excess and ostentation were glorified: "If you've got it, flaunt it" was the mantra of the newly rich.

The International magazine was the first to publish Aleister Crowley's essay "Cocaine."

MARIUS PÉGOMAS

DÉTECTIVE MARSEILLAIS

par Pierre YRONDY

LE ROI DE LA NEIGE

UN FRANC

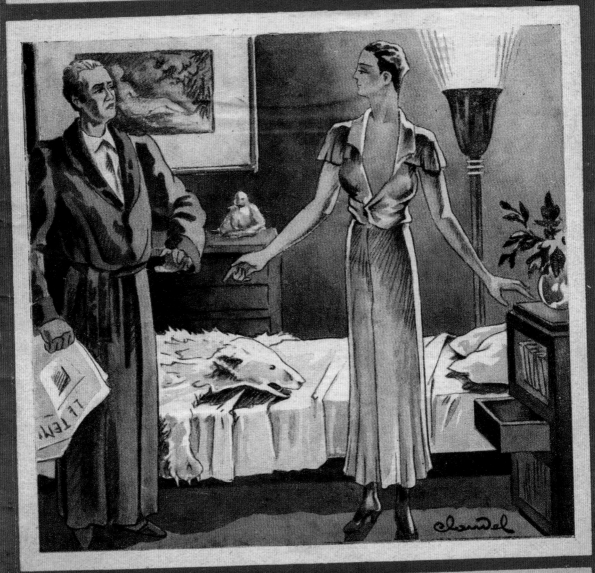

Roman complet et inédit.

Editions Baudinière.

EDWARD J. MAYSON

COCAÏNE

ou CONSEILS A UN AMI

paroles de GEORGES ANCHARD

SHIMMY-FOX

PIANO ET CHANT..FR 2 _ NET.
ORCHESTRE _ FR 2 _ NET.

Propriété de l'Éditeur
MAX ESCHIG
ÉDITEUR DE MUSIQUE
48, RUE DE ROME A PARIS
TOUS DROITS D'EXÉCUTION DE
TRADUCTION DE REPRODUCTION
ET D'ARRANGEMENTS RÉSERVÉS
POUR TOUS PAYS.

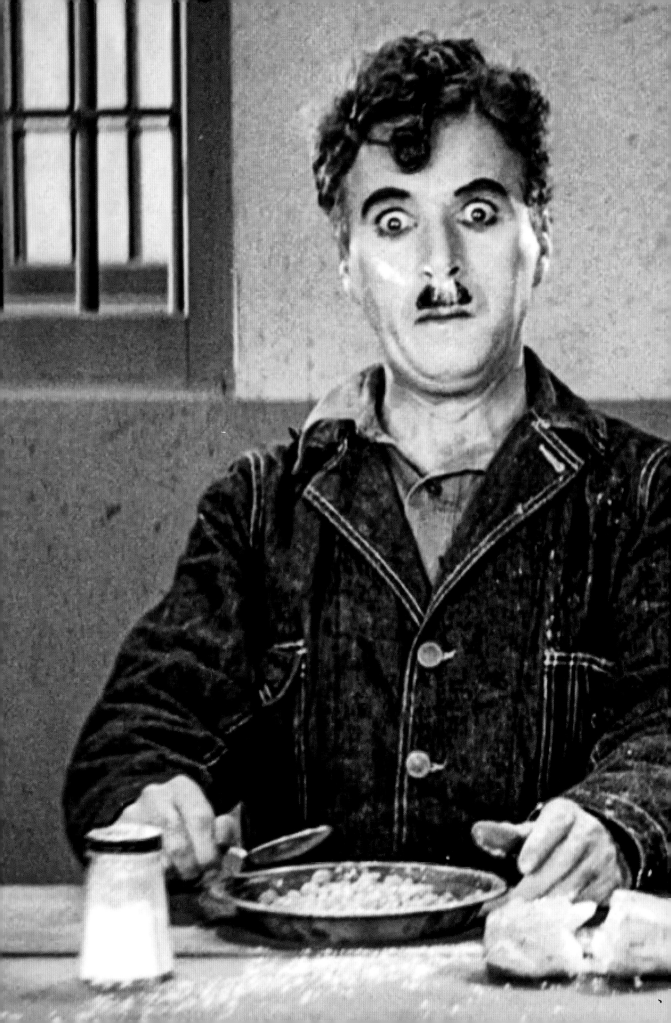

It's been widely accepted that coca has been consumed in the Andes for about 3,000 years, but more recent archaeological evidence suggests that it was a part of cultures there as far back 8,000 years.

In the 1936 film *Modern Times*, written and directed by Charlie Chaplin, Chaplin's character accidentally ingests smuggled cocaine while employed on an assembly line.

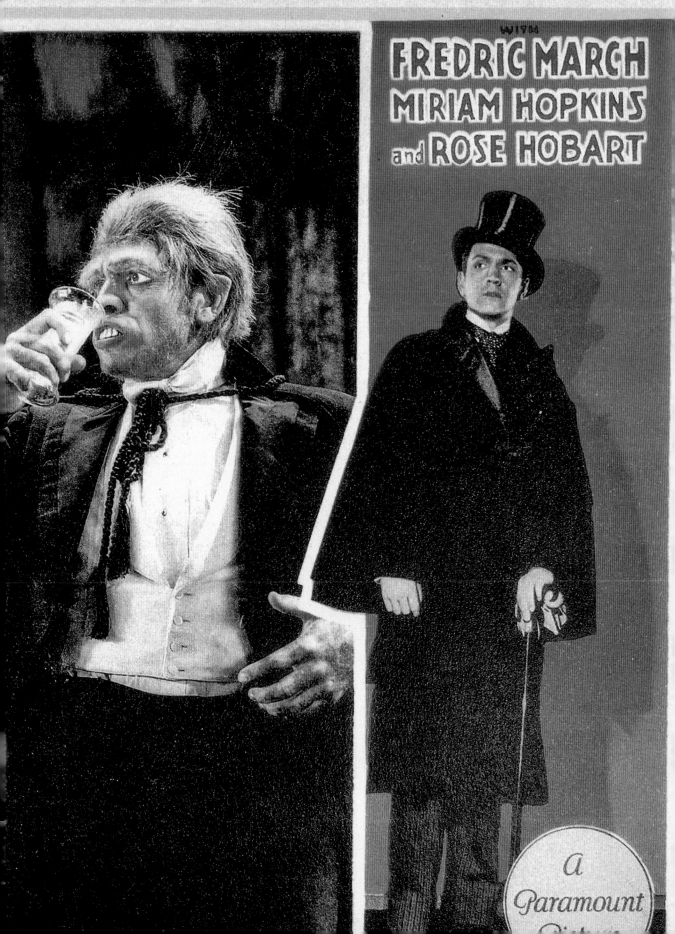

" *I suppose that its influence is physically a bad one. I find it, however, so transcendently stimulating and clarifying to the mind that its secondary action is a matter of small moment.* "

SIR ARTHUR CONAN DOYLE
THE SIGN OF FOUR, 1890

An alternate poster for *Cocaine Fiends,* 1935. *Page 108:* The illustration *Marius Pégomas, Détective Marseillais, le Roi de la Neige* by Pierre Yrondy, 1936. *Page 109:* An illustration of the musical score for the song "Cocaïne ou Conseils à un Ami," 1921.

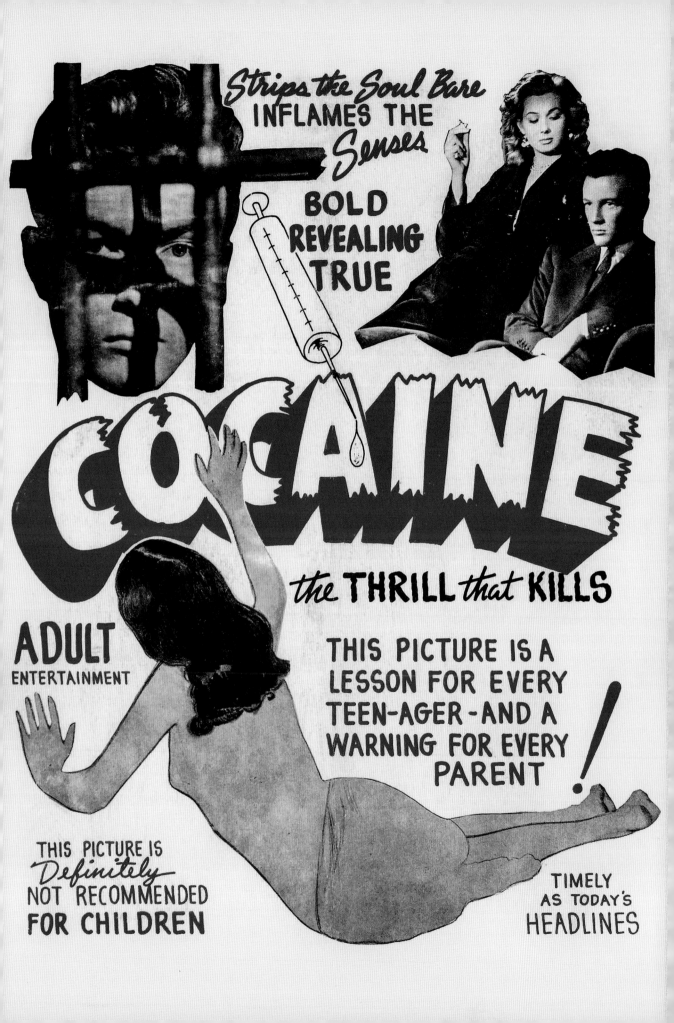

Fosco **GIACHETTI**

Jacques **SERNAS**

Olga **VILLI**

COCAÏNE

Cocaine became a status signifier, enhanced by countless fashion designers, actors, and pop stars who practically endorsed it as a lifestyle choice.

The apotheosis of this scene was Studio 54 in New York. Though the nightclub was open for only 33 months, from 1977 to 1980, it epitomized the confluence of glamour, celebrity, money, and debauchery with which cocaine came to be associated. Bianca Jagger famously gallivanted on the dance floor one night atop a white horse. The club was transformed into a farm, complete with livestock, for a visit from Dolly Parton. Fashion star Valentino celebrated his birthday with a circus-themed bash that included mermaids on trapezes and costumes originally designed for the Federico Fellini film *The Clowns*.

Those parties were the stuff of legend, and they were openly fueled by cocaine. Aside from the "rubber room" for casual sex located in the balcony, the dingy VIP basement where anything could happen, and the antics of regulars like Halston, Andy Warhol, and Liza Minnelli, Studio 54 will be forever remembered for its large smiling moon above the dance floor, which lit up during particularly euphoric moments when a mechanical spoon was pressed to its celestial nose.

The bigger the party, the harder the hangover, and cocaine's second coming was no exception. Studio 54's run famously ended with a tax evasion jail sentence for its owners, Steve Rubell and Ian Schrager, after bags of cash were found in the club's rafters during a police raid. (The party ended earlier and even more abruptly for one unfortunate crasher, who tried to infiltrate the club via an air shaft, got stuck, and died there.) By the time the 1980s rolled around, the carefree days of disco seemed like a distant memory. The first cases of AIDS began to be publicized, and crack, a powerful, cheap, and decidedly non-aspirational base form of cocaine that could be smoked or injected, started its relentless spread.

The journalists and government officials who had spoken so casually about cocaine had failed to take one small detail into consideration: What would happen if its price bottomed out? Could it be that relatively few people had become addicted to it because relatively few people had had the means to use it regularly? It was the same story that had played out a hundred years earlier.

By the early 1980s, cocaine had become a massive, multinational business, and kingpins were not about to simply walk away from one of the most lucrative markets in history. The drug wars that ensued and that rage on to this day have been famously depicted in films like *Scarface* and series like *Narcos*, and they appear to be here to stay. Hundreds of thousands have died—not just from overdoses but also because cocaine is now directly

A Belgian poster for the Italian movie *Cocaine*, released in 1948. *Pages 112-113*: Supposedly, Robert Louis Stevenson wrote most of *The Strange Case of Dr. Jeykll and Mr. Hyde* under the influence of cocaine.

linked to the financing of terrorism and corrupt governments, the rise of transnational gangs, and the displacement of entire populations.

Considering the enormous trail of destruction that cocaine has left in its wake, the images in this book capture a time that seems, in retrospect, to be woefully naïve. It's ironic that the countries that have suffered the most in this long saga are not those that created, refined, and popularized the drug; instead, cocaine hit hardest the less-developed nations in which the coca leaf had been used harmlessly, in its natural state, for thousands of years.

But that is another story, and one best left for another time.

An illustration of "Cocaine, a Worldwide Scourge" from a 1930 edition of *L'Animateur des Temps Nouveaux.*
Opposite: The cover of *Les Forçats de la Neige* by Marcel Nadaud and André Rage, 1926.

LES FORÇATS

DE LA

"NEIGE"

PAR MARCEL NADAUD & ANDRÉ FAGE

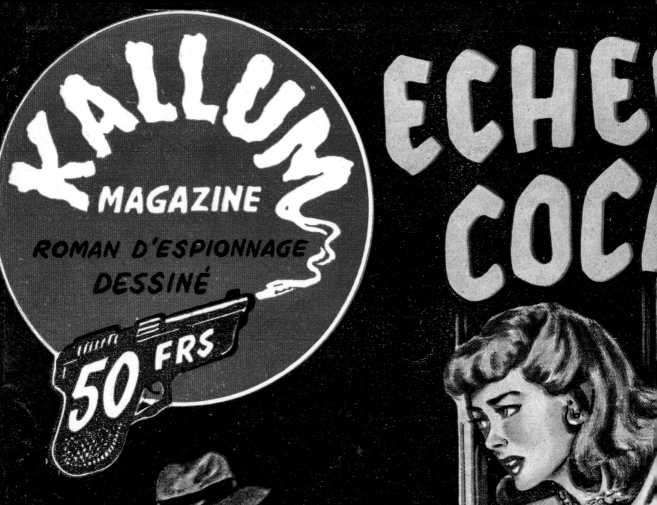

KALLUM
MAGAZINE

ROMAN D'ESPIONNAGE
DESSINÉ

50 FRS

ECHE
COC

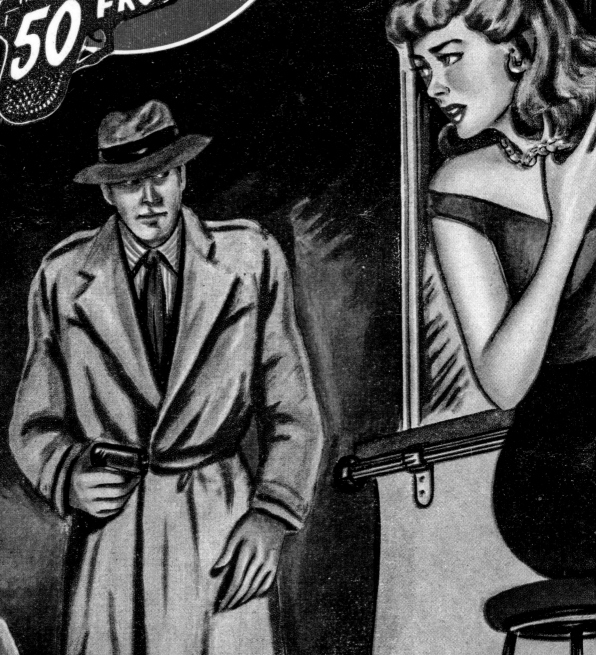

When the Spanish conquistadores arrived in South America, shortly after Christopher Columbus's discovery of the New World, they found an almost limitless natural bounty.

Frank Peter Belinda's illustration of "Échec à la Cocaïne" for *Kallum Magazine,* 1953.

66 *For I have seen love and his face is choice Heart of Hearts, a flesh of pure fire, fusing from the center where all Motion is one.* 99

JOHN WEINERS
FROM THE POEM "COCAINE," 1986

A movie poster for the 1922 film *Cocaine*, directed by Graham Cutts. *Following pages:* (*left*) The rare book *Dope Darling: A Story of Cocaine*, published in 1919. (*right*) "La Coco" graces the front cover of *La Charrette "Charrie,"* 1923.

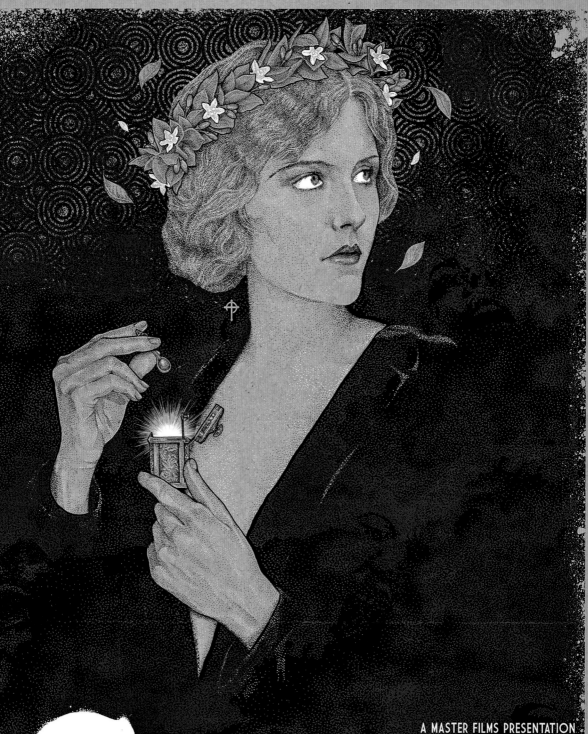

A MASTER FILMS PRESENTATION

Cocaine

HILDA BAYLEY FLORA LE BRETON TONY FRASER

WRITTEN BY FRANK MILLER PRODUCED BY H.B. PARKINSON DIRECTED BY GRAHAM CUTTS

#110878-051912-10

Screen Printed in the USA By VGKIDS.

DOPE DARLING
A STORY OF COCAINE

NUMÉRO 24.
Deuxième Année.

LE NUMÉRO : 1 Fr. 25
Étranger : 1 Fr. 75.

La Charrette "charrie"

aujourd'hui

LA COCO

Dessins de J.=C. BELLAIGUE
Texte par CYRIL-BERGER, José GERMAIN,
André WARNOD et Michel HERBERT

AT HOME WITH BILL BURROUGHS

HIGH TIMES

K-48427

MARCH 1985

$3.50

Cocaine '85

The Pleasures and Perils of "the All-American Drug"

Art Against War

High on Movies

Nightmares
And Creativity

71896 48427 03

This issue of "High Times" was headlined "Cocaine '85: The Pleasures and Perils of the All-American Drug," 1985.

> 66 *If you got bad news; You want to kick the blues, Cocaine. When your day is done, And you want to ride on, Cocaine.* 99

ERIC CLAPTON
"COCAINE," 1977

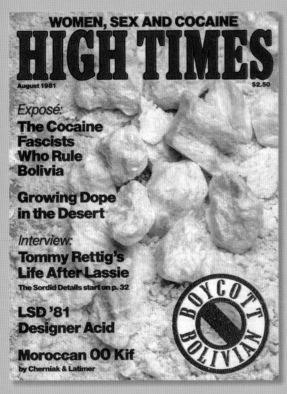

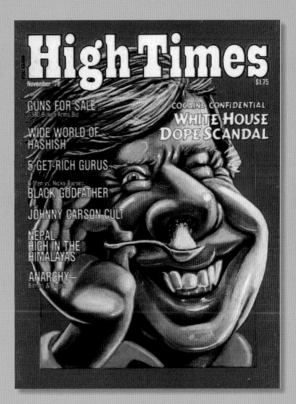

The August 1981 cover of "High Times" promised an exposé on "The Cocaine Fascists Who Rule Bolivia."

The March 1978 cover of "High Times" featured an illustration of former president Jimmy Carter ingesting cocaine.

Following pages: (*left*) Martin Scorsese's classic film *Scarface*, a remake of a Howard Hawks film, stars Al Pacino as a nobody who rises to become one of the most sought-after drug kingpins of Miami. (*right*) A movie poster for the original *Scarface* film, 1932.

AL PACINO SCARFACE

In the spring of 1980,
the port at Mariel Harbor
was opened, and thousands
set sail for the United States.
They came in search
of the American Dream.

One of them found it on the
sun-washed avenues of
Miami...wealth, power and
passion beyond
his wildest dreams.

He was Tony Montana.
The world will remember
him by another name
...SCARFACE.

A MARTIN BREGMAN
PRODUCTION

A BRIAN De PALMA
FILM

AL PACINO
"SCARFACE"

SCREENPLAY BY
OLIVER STONE

MUSIC BY
GIORGIO MORODER

DIRECTOR OF PHOTOGRAPHY
JOHN A. ALONZO
A.S.C.

EXECUTIVE PRODUCER
LOUIS A. STROLLER

PRODUCED BY
MARTIN BREGMAN

DIRECTED BY
BRIAN De PALMA

He loved the American Dream.
With a vengeance.

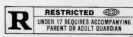

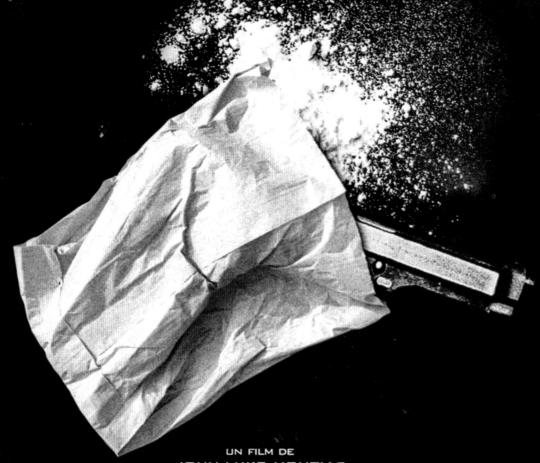

LES FILMS DE L'ASTRE
PRÉSENTENT

Dans ce milieu
mieux vaut savoir nager

UN FILM DE
JOHN-LUKE MONTIAS

BOBBY G.

(Can't Swim)

A seizure of over 860 kilograms of cocaine in Santo Domingo, Dominican Republic, 2017.

Bobby G. Can't Swim, a 1999 film by John-Luke Montias, features small-time coke dealer Bobby G.'s attempts to go big with his business. *Following pages:* New Yorkers await admission into the city's famed Studio 54 club, 1978.

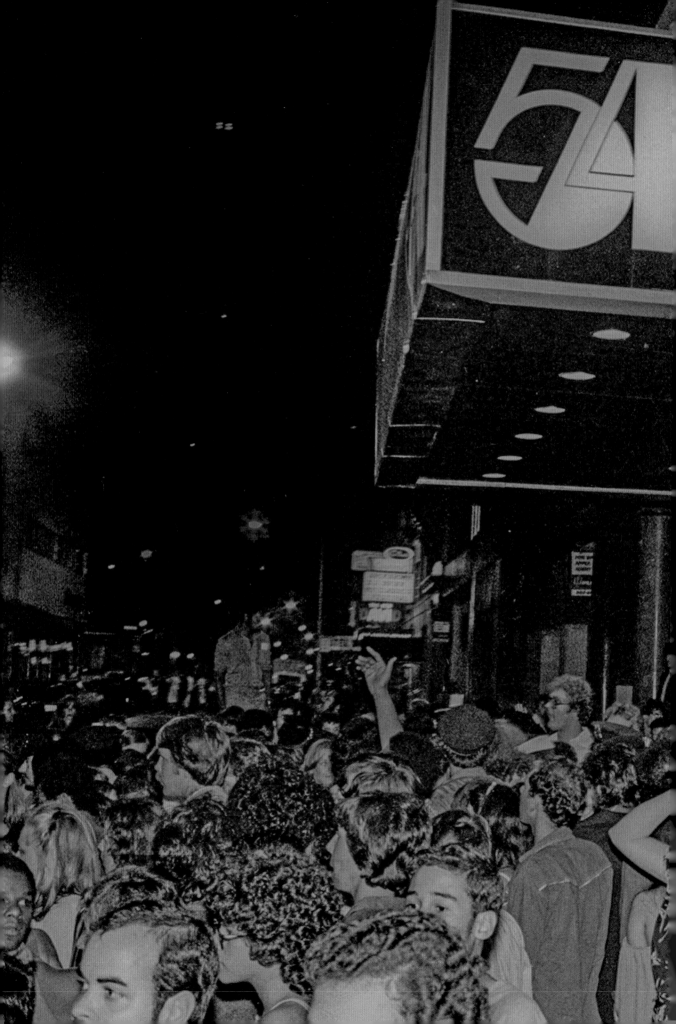

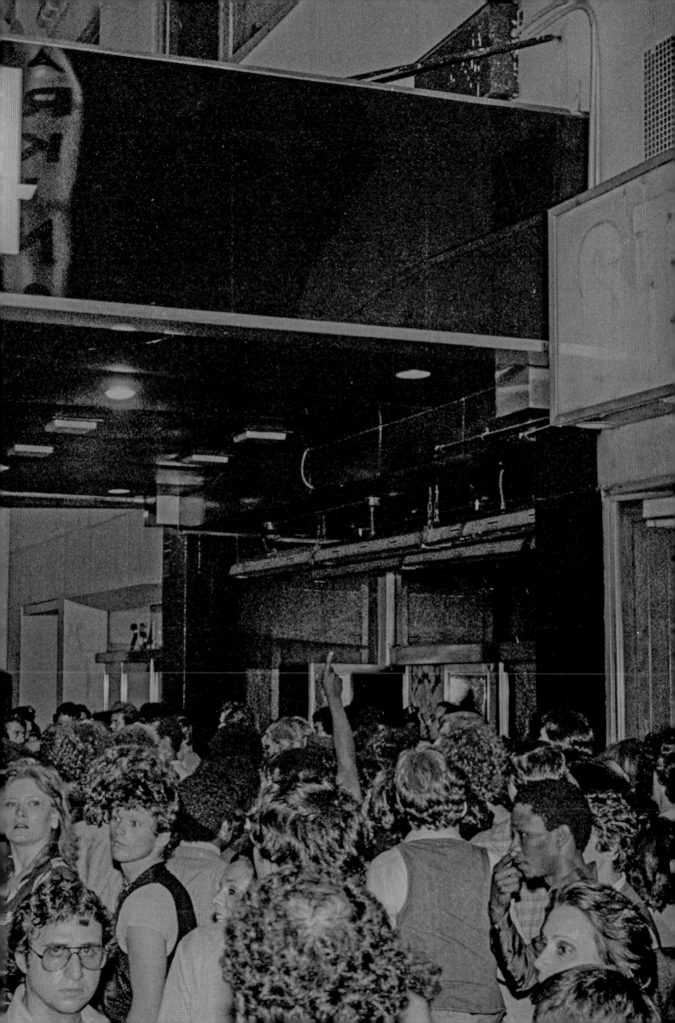

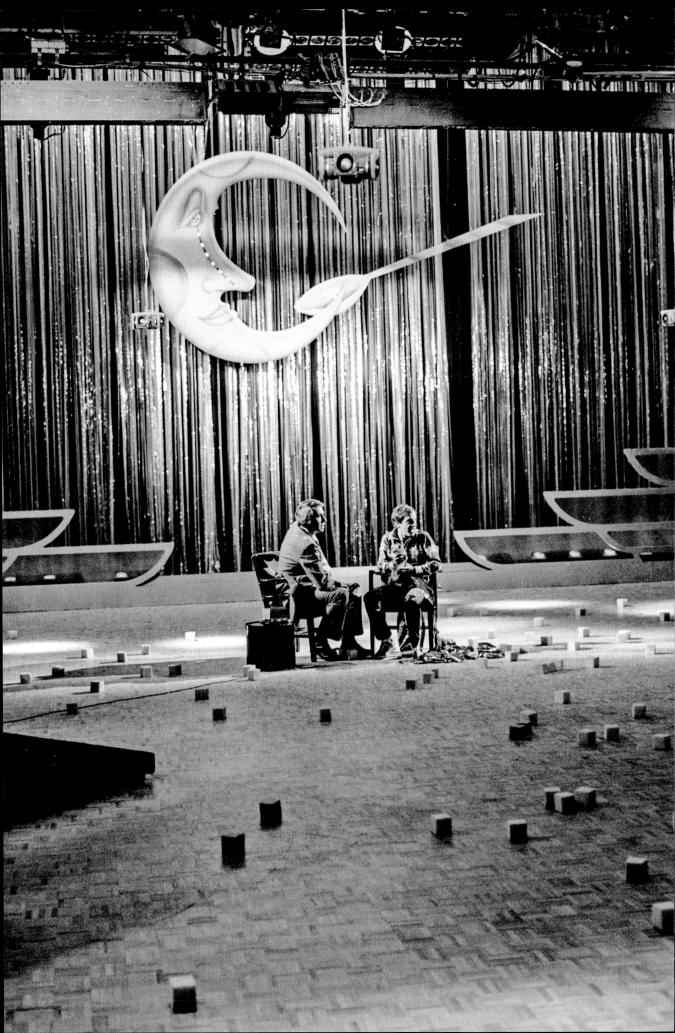

Acknowledgments

The publisher would like to thank the following individuals and organizations for their contributions to this book: Frannie Ruch; Timothy Pittides; Throop Pharmacy Museum; The National Museum of American History; Science and Society Photo Library; Harvard Library; The Royal Pharmaceutical Society of Great Britain; Weiser Antiquarian Books; High Times; Wm. Morford Antiques; The Herb Museum; History of Pharmacy Museum, University of Arizona College of Pharmacy; and The Wellcome Collection.

Armand Limnander is the executive editor of *W Magazine*. Prior to that, he was features director at *T: The New York Times Style Magazine*, the editor of *VMan* magazine, and a senior writer at *Vogue* and Style.com. Limnander grew up in Bogotá, Colombia, and moved to the United States to attend the University of California at Berkeley. His books *Brazilian Style* and *Private: Giancarlo Giammetti* were published by Assouline in 2011 and 2013, respectively.

Tom Snyder, host of *The Tomorrow Show,* interviews Studio 54 co-owner Steve Rubell, 1978.

Credits

Thanks to the following for their contributions to the book: Jennifer Belt and Ken Johnston at Art Resource, M. Fernanda Meza and ARS, Thomas Haggerty and Bridgeman Images, Starr Hackwelder, Alamy, Brian Stehlin and Getty Images, and Silka Quintero at Granger Historical Picture Archive.

© 2018 Assouline Publishing
3 Park Avenue, 27th Floor
New York, NY 10016, USA
Tel.: 212-989-6769 Fax: 212-647-0005
www.assouline.com

Editorial director: Esther Kremer
Art director: Jihyun Kim
Designer: Vanessa Geammal
Senior Photo Editor: Ashley Wu
Photo research: Frannie Ruch
Editor: Jansel Murad
ISBN: 9781614287551
Printed in China.